Cole Weston

FIFTY YEARS

Introduction by Cole Weston
Afterword by R. H. Cravens

GIBBS·SMITH
P
PUBLISHER

PEREGRINE SMITH BOOKS

SALT LAKE CITY

First edition.
Copyright © 1991 by Cole Weston

Published by Gibbs Smith, Publisher
Peregrine Smith Books
P.O. Box 667
Layton, Utah 84041

Design by J. Scott Knudsen

Manufactured in Singapore

Library of Congress Cataloging-in-Publication Data

Weston, Cole.
 Cole Weston—fifty years / Cole Weston
 p. cm.
 ISBN 0-87905-381-X
 1. Photography, Artistic. 2. Weston, Cole. I. Title.
II. Title: Cole Weston—50 years.
TR654.W446 1991
779' .092—dc20 91-8362

To my children,

grandchildren,

and Paulette

INTRODUCTION

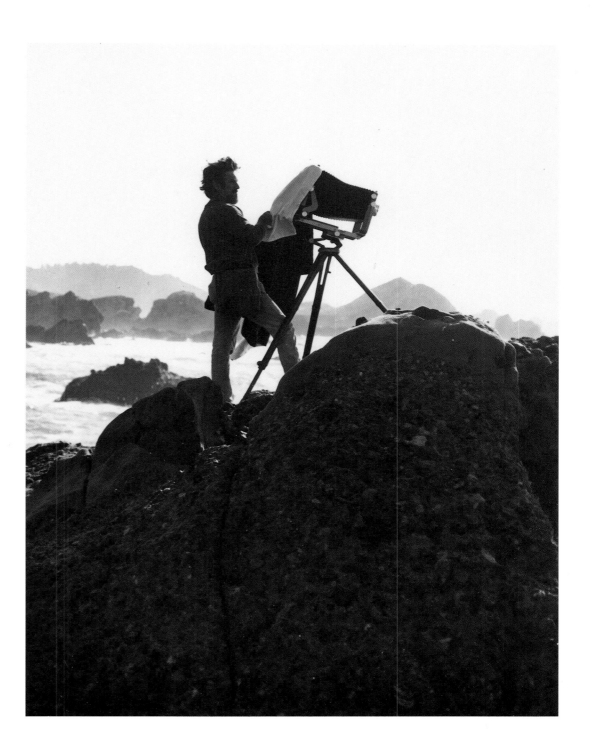

**At Point Lobos, 1960.
(Photo by Kim Weston.)**

Although photography is a way of life in our family, I wasn't sure in the beginning if it was a birthright or a birthmark—something I'd rather hide. Being the youngest of Edward Weston's four sons (born January 30, 1919) was not always easy. An example was that unforgettable evening when I was just out of high school and attending the Cornish School of Drama in Seattle, Washington. Nellie Cornish introduced me to Shankar, the great dancer from India, saying, "This is Cole Weston, Mr. Shan-kar. He's famous only because of his father." Remarks like that sting when you're a teenager. Also, it was fairly intimidating that my older brother, Brett, had started building an international reputation at the age of seventeen, when twenty of his prints were shown at the world-famous 1929 "Film and Foto" show in Stuttgart. A half-century later, I can still summon up the mixed feelings I once had about the medium.

Among my earliest memories is pushing a toy speedboat around in my father's darkroom sink in his Tropico (now Glendale), California, studio. It was also there that my brother, Neil, and I had to wash off emulsion and obliterate images from Dad's glass negatives to replace windows we'd broken. That old studio held other strange memories for me. I recall Dad asking me to go out and watch for the red streetcar: a young lady visitor, I think it was Olive Taylor, had to catch her ride back to Los Angeles. I went out, but sneaked back and found my father in a close embrace with the woman in his darkroom. So you see, my beginning in photography was with some rather mixed emotions.

It was Brett who introduced me to hands-on photography. Neither of us can remember the date precisely, but in 1927 or a little later he took me to Mt. Wilson, where I made my first image—a black-and-white picture of the observatories. Brett also taught me the basics of darkroom technique in his Santa Monica studio. When I'm asked at workshops, "Have you taken lessons in photography?" the answer is "no." I learned by a kind of osmosis from two great photographers, and also from being surrounded by

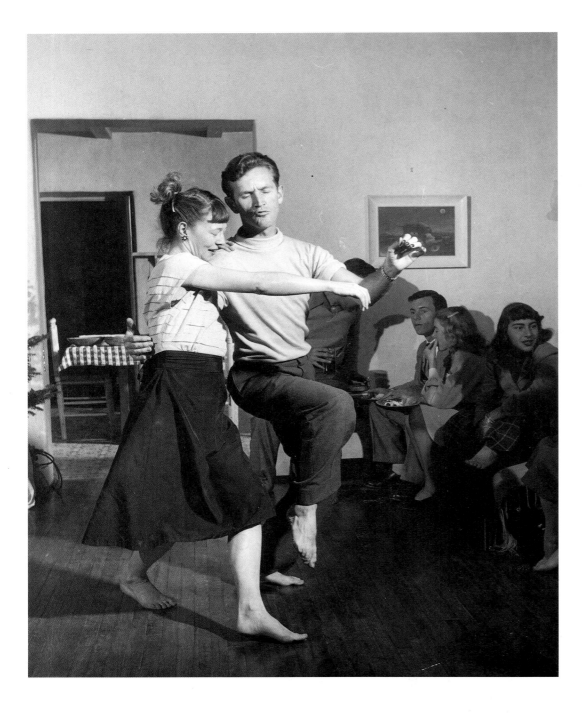

Dancing at Peter Stackpole's with first wife, Dorothy, 1940.

After I'd finished high school in 1937 (the only Weston son to graduate) Dad arranged with his old friend—the above-mentioned Nellie—for me to enter the Cornish School. It was then one of the best drama schools in the country. Visiting teachers included Martha Graham and luminaries from the Moscow Art Theater, which was revolutionizing acting in New York at the American Place Theater. We were luckier than New York actors and directors: we received our Stanislavsky theory undiluted by what later became known as "the method."

The three years I spent in Seattle were a great experience, but after I graduated in 1940 the country was gearing up for the real-life drama of World War Two. I went to work for two years as a metal smithing foreman at Lockheed, building bombers for Britain and P-38 fighters. Having been raised by the sea, it was natural for me to enlist in the navy. I was then posted for the duration as a landlocked sailor and public relations photographer at a naval base in Norman, Oklahoma.

Upon discharge, I became a photographer for *Life* magazine on a retainer basis for about six months. It didn't work out too well because I'd been trained by my father to make one or two exposures of a subject. Either you had your image or you didn't. *Life,* however, expected its photographers to shoot rolls of film. When they'd receive my one or two exposed frames the editors were always complaining, "Where's the rest?" I did get one memorable photograph for them. From a blimp, I got an overhead shot of the largest airplane ever built up to that time—Howard Hughes's plywood *Spruce Goose*—casting surreal shadows as it was being moved along the highway from Santa Monica to Long Beach.

The really decisive event which fixed me in a photographic career was a request from my father in 1946. I had traveled back to New York for the Edward Weston Retrospective at the Museum of Modern Art. Curated by Nancy and Beaumont Newhall, it was one of the great exhibitions in the history of the medium. Ironically, this crowning moment in my dad's career also marked the moment when his life began unraveling. His marriage to the writer Charis Wilson, the subject of some of his finest nudes, was disintegrating. He'd also just been diagnosed with Parkinson's disease. Dad needed an assistant, and when he asked me I couldn't refuse.

I moved to Carmel and followed a Weston tradition that none of us ever liked—setting up a portrait studio. Fortunately, my portrait business mostly dried up when I ran for Congress in 1948 on Henry Wallace's ultra-liberal Independent Progressive party

photographers, photographs, and darkrooms all my life. I guess photography is in my blood.

My first ambition, however, was the theater. I'd been raised in Carmel, California, which almost from its founding was one of the most stage-struck towns in America. In Howard and Ann Gilliam's delightful history of Carmel, they quote a New York drama critic who characterized our village in the 1920s as an "artists' colony, where nine plays were in rehearsal in one July and where the population appears to include 2,000 actors and no audience." It was also in Carmel where the first American performances were staged of Kurt Weill's *Threepenny Opera,* as well as premiers of plays by Robinson Jeffers (with Judith Anderson performing) and Jack London.

ticket. Dad enjoyed the campaign immensely. Meanwhile, I was the object of a lot of Red-baiting, which scared off the portrait customers. I moved the family ten miles south to Garrapata, where I started a trout farm that provided our living for the next ten years. Far more importantly, every day I drove to Carmel to be with Dad; I was involved in one of photography's most unique relationships.

As Dad's assistant, I mounted his shows and handled his business affairs. After his death in 1958, I became what you might call the "keeper of the flame." The core of the work, which went on for more than thirty years, was printing Edward Weston negatives. I once described the process this way:

"Printing each [negative] is a tense experience, requiring exact exposures—invariably with an initial test strip to adjust for variations in the speed and contrast of the photographic paper. About fifty percent of his negatives required burning and dodging to achieve his desired effect. . . .

"In the beginning, he would come into the darkroom with me. We might spend an entire day on a single negative. Later, I would go into the darkroom and emerge with a print. He would criticize it . . . and I would go back in and try again. We worked in such painstaking detail on a hundred or more negatives. [His] exactness was maddening at times. . . ."

Under the terms of Dad's will, each of these images was to be stamped on the back: "Negative by Edward Weston, Print by Cole Weston."

He had wanted the prints to keep on emerging for two reasons. First, he foresaw rightly that they would be a source of income for his family. He also believed in a kind of democracy of photography— that anyone should be able to own and live with a great photographic image.

Luckily for my own development as a photographer, I started working with color in the late forties. In 1947, Eastman Kodak sent Dad several boxes of 8×10 Kodachrome with a 14-inch Ektar lens and we went to Point Lobos. The illness was robbing Dad of his motor faculties, so I helped him by adjusting the tripod and placing his fingers on the focussing knobs. In fact, he only had a few more months of being able to work and made approximately fifty images. I wound up using the color film left in the holders, and after Dad stopped photographing, Eastman Kodak kept me supplied with Kodachrome. I soon gave up black-and-white altogether.

In the fifties, my wife Helen and I were raising four children, which pretty much confined me to photographing along the Monterey Coast. I began to acquire a reputation as a seascape photographer, and my

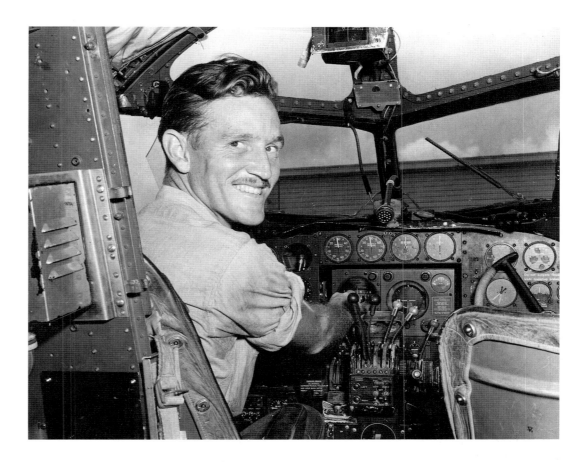

At the controls of a grounded bomber during navy years, 1943-45.

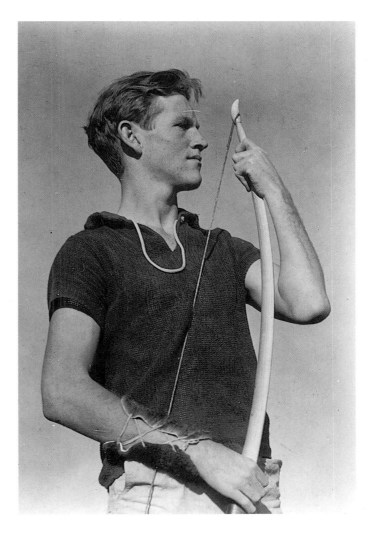

Practicing archery, 1935.

Feeding trout, Garrapata
Canyon.

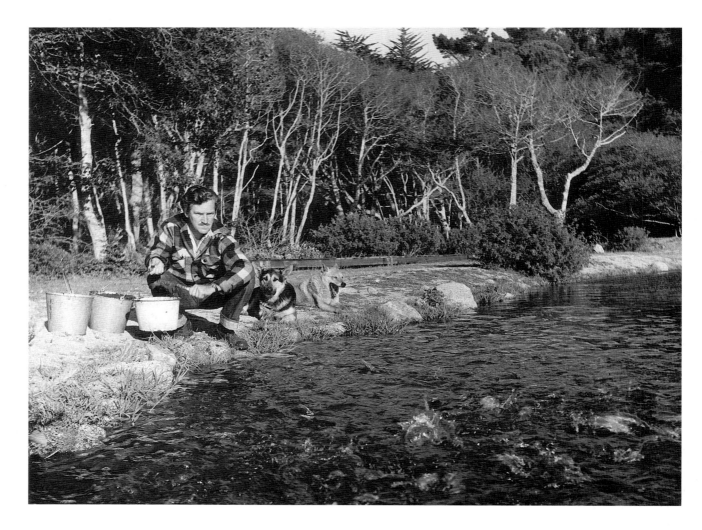

With children Matthew and
Cara on my 50-foot steel Dutch
ketch, *Scaldis,* which I have
sailed 50,000 miles—to Central
America, Mexico, South
America, Jamaica, Bermuda,
South Seas and Galapagos,
Marquesas, and Tahiti.

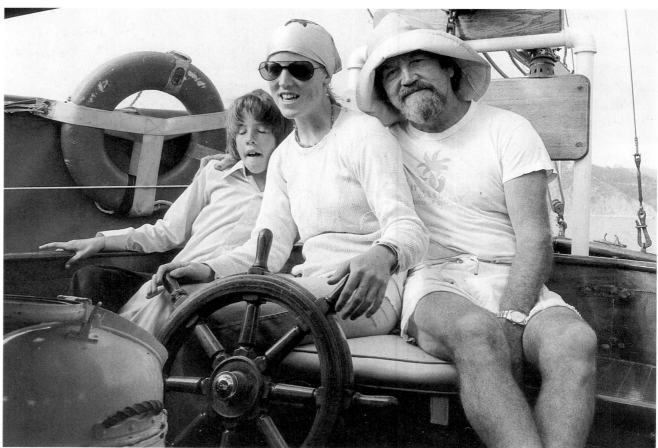

images were used for calendars, record albums, and books. My best-known photograph, *Surf and Headlands, 1958,* appeared on the cover of *Not Man Apart,* a Sierra Club blockbuster (serialized by *Reader's Digest*) that landed on the cocktail tables (or in the bathrooms) of an estimated 20 million viewers. I didn't have the artistic stature of either my father or brother, but my work was more widely seen.

In the years that followed, I began branching out geographically and vocationally. I had already made some photographic expeditions throughout the West, especially into desert and mountain country. In 1968, I managed to acquire an extraordinary yacht—a fifty-foot, Dutch-built steel ketch, *Scaldis.* Already forty-five years old when purchased, she had a colorful history that included being commandeered by the Nazis in World War Two. My sons and I have added to her history long voyages to the Caribbean and the South Seas where, for reasons of sheer portability, I've occasionally used a 35-mm camera instead of my preferred 8×10.

I also continued working with Carmel's Forest Theater. It is an association that, as of this writing, has gone on for forty years and includes directing more than twenty plays—among the most recent, O'Neil's *Long Day's Journey Into Night.*

Those years of working in the theater helped prepare me, I think, for what has become one of the most gratifying aspects of my career: teaching. This began in the mid-seventies with an invitation to do a workshop on Edward Weston. Since then, I've expanded the subject matter and held workshops from California to Europe—in places as diverse as New Zealand, Holland, France, Italy, and the Soviet Union. I've also taught in most parts of the United States.

There is an interesting parallel between directing a play and teaching. In the theater, there are times when you find incredible talent that just seems to come out of nowhere. You help people discover gifts they didn't know they had—start them along a path of self-discovery. That happens in teaching, too. However, in classes, it's not so much trying to teach people to be great artists. The real satisfaction is in helping them discover their gift for *seeing.* We are so overwhelmed by images in the modern world that we wind up with a numbed capacity to see nature, to see the world we live in and the relationships we live with. There is incredible excitement for me in watching a workshop participant start lifting the veil from his or her eyes and begin discovering a unique personal vision that may have nothing whatsoever to do with making artworks. Happily, living with that

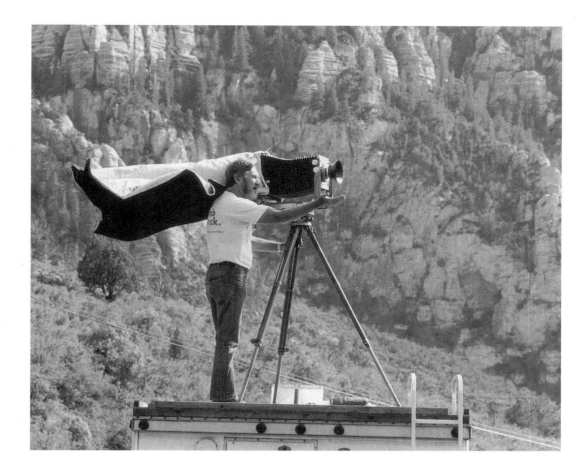

vision not only is a lifelong process, but also one of continual rediscovery.

In 1988, I fulfilled a longstanding promise to myself to quit working with Edward Weston negatives. I determined to devote the rest of my life to my own photography and to find out how far I could take it. The photographs in this book extend over a thirty-two-year period (and also include my first two black-and-whites from fifty years ago), but half of them have been made since 1980. If photography was indeed my birthright, I waited a long time to claim it. But the wait was worth it! I have never been so passionately involved with photography, never so excited by its possibilities.

I'm often asked in workshops for my views or philosophy of color photography. I usually draw my audience's attention to two observations my father published in an article in 1947. I still find them remarkable insights, especially because his own working contact with color imagery was so brief.

The first observation was that black-and-white and color photography are two distinct mediums. The latter is not an offshoot nor a stepchild. The post-World War Two breakthroughs in color technology were in a way as revolutionary as the invention of the medium itself. As an aside, I might mention

Photographing with my Alaskan camper, Sedona, Arizona, 1978. (Photo by John Boland.)

If we grasp that color photography is a unique and distinct medium, then we begin to approach it with fresh eyes. We need to see it differently. And that leads to Dad's second observation, a simple concept that can be very difficult to grasp. He wrote, "See color as form." Black-and-white photography has the advantage of revealing form in nature more easily, mainly because it is an unnatural medium. We see—most of us—in color, and when color is taken away, forms are emphasized. To see color as form means looking at the image in a new way, trying to free oneself from absorption in subject matter.

As for my own photography, it's much harder to talk about. I see certain influences. For most of my adult life, I worked with Edward Weston images, an intimate relationship with beauty few can imagine. I have no qualms about photographing something simply because it is beautiful. Also, I've had a lifelong, deep commitment to the theater, and I recognize a theatrical quality in much of my work. I also think I've crossed over some kind of threshold in pursuit of those new images that I know are out there, waiting.

With Dad's photographs, I sought the exact reenactment of his creativity. In the theater, I've tried to interpret the playwright's creation. Now, I'm after my interpretation of Creation itself.

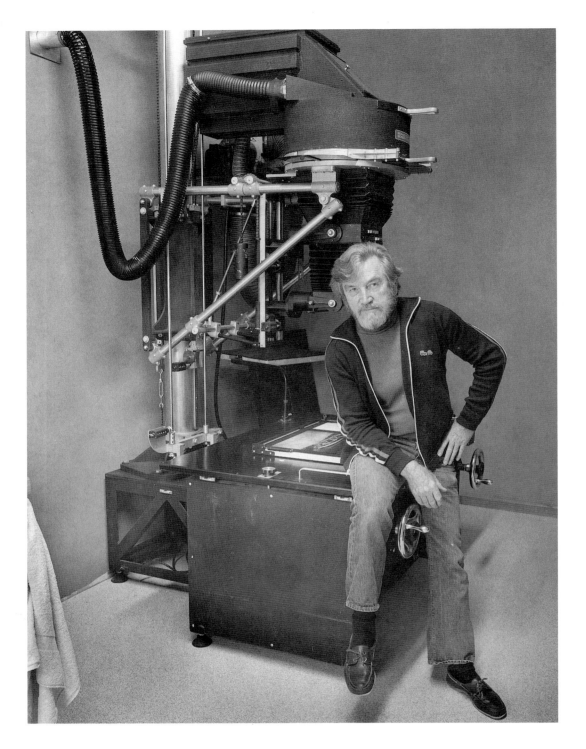

In the darkroom with my one-ton Salzman enlarger. (Photo by Carolyn Caddes.)

that technology has played a role in my most recent work. Having worked in darkrooms all my life, I've never been satisfied with sending my color film off to a lab for processing—a practice some of our leading photographers find acceptable. Until a few years ago, I'd never had an enlarger that would handle the 8×10 transparencies. Now I have an 8×10 Salzman enlarger fitted with a super Chromega Dichroic color head. It's a monstrous machine, weighing a ton, but it gives me the direct personal control I must have over prints.

At a workshop in North Carolina. (Photo by student Craig Roberts.)

In Death Valley, 1987. (Photo by Ted Weston, first grandson of Edward Weston.)

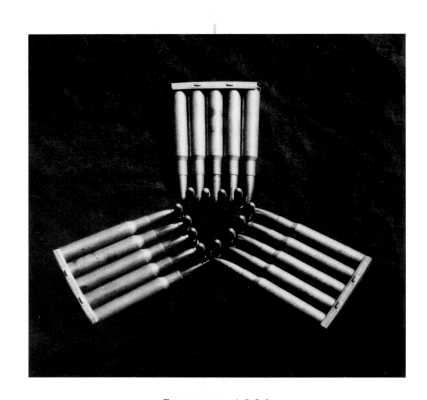

SHELLS, 1930

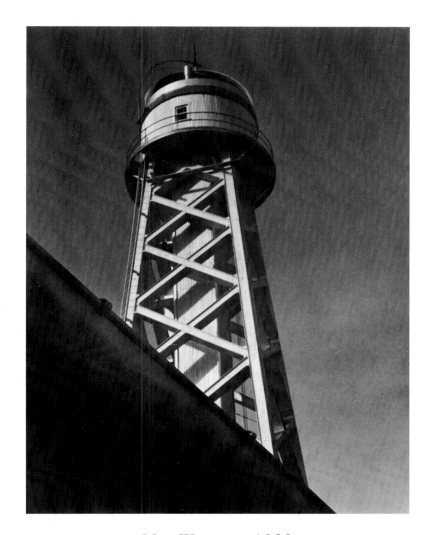

MT. WILSON, 1932

SOBRANTES POINT

BIG SUR, CALIFORNIA

1958

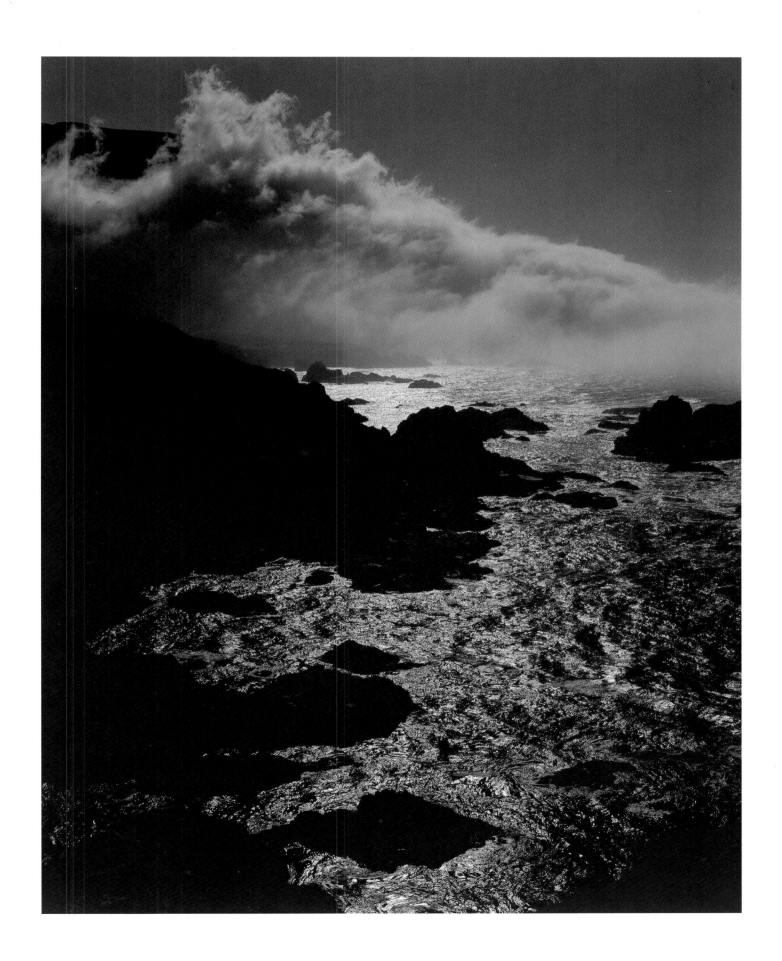

ST. GEORGES

BERMUDA

1970

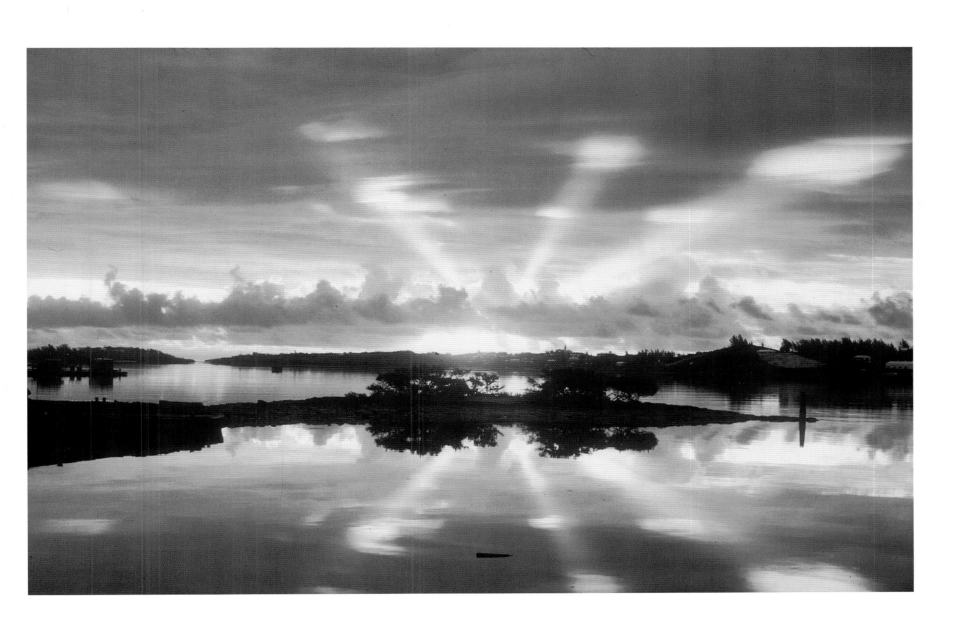

DESERTED SHACK

CALIFORNIA

1971

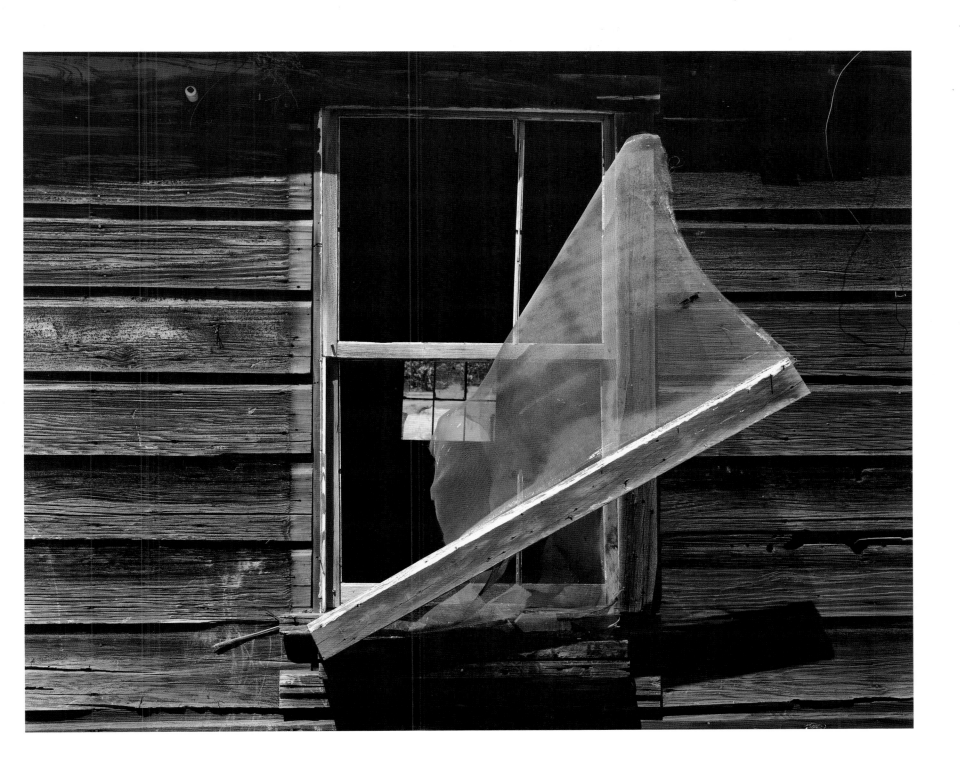

SEALS

GALAPAGOS ISLANDS

1973

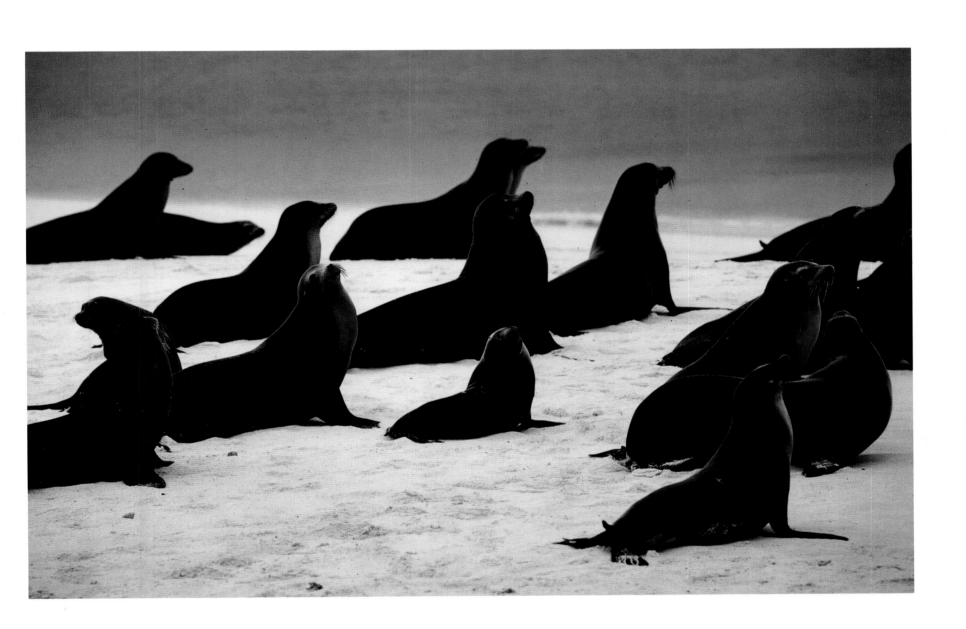

MOTU-TOPU

BORA BORA

1974

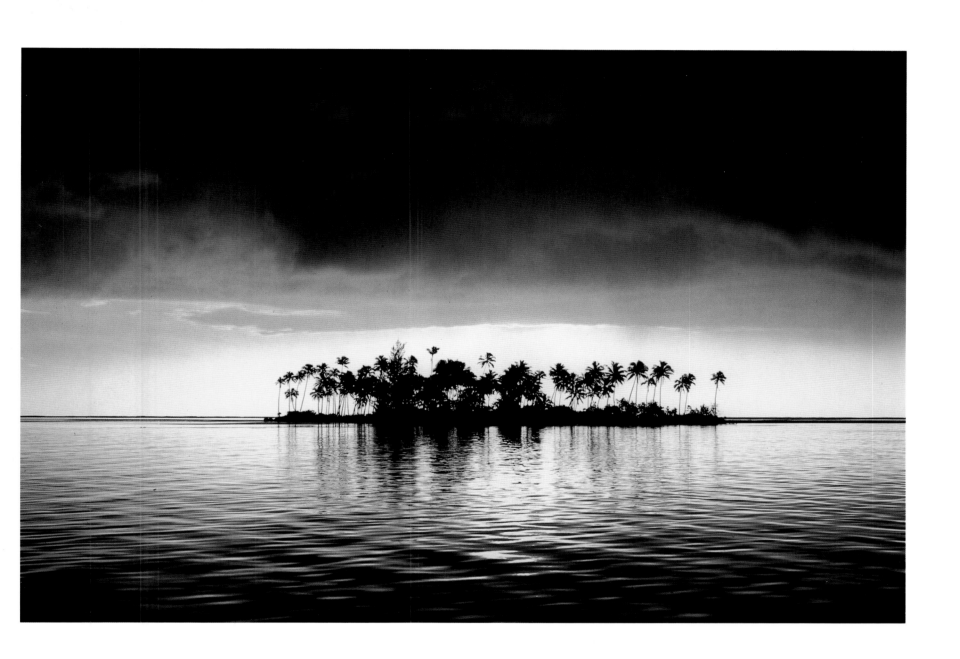

POPLARS

NEW ZEALAND

1976

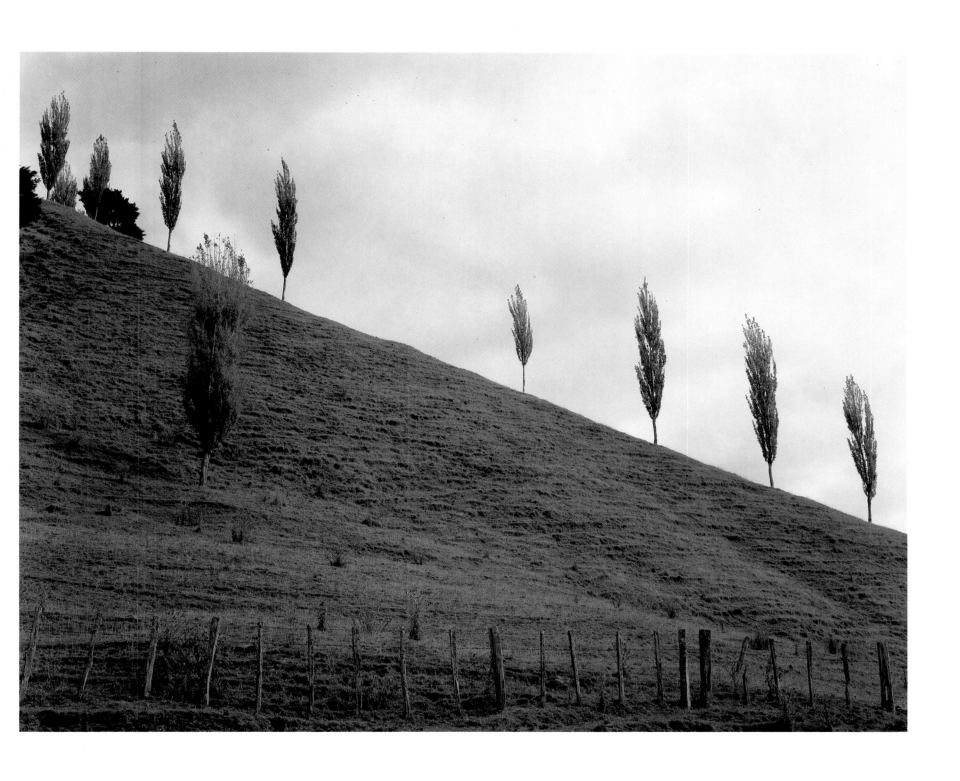

CREEK BED

LAKE POWELL, UTAH

1976

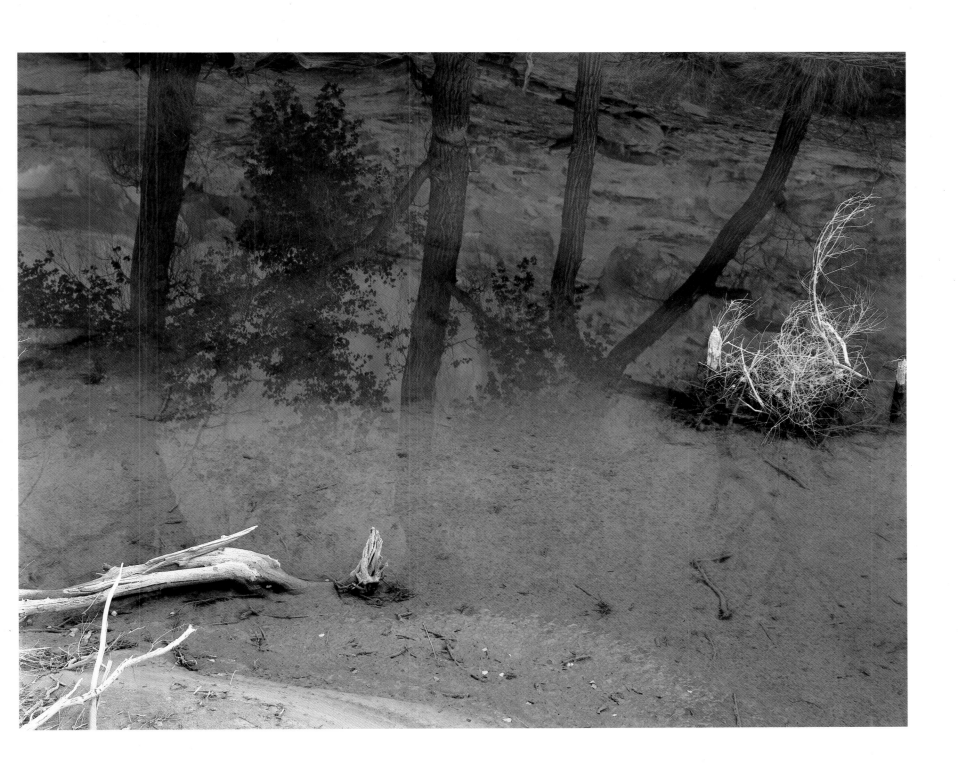

BRISTLECONE PINES

CALIFORNIA

1977

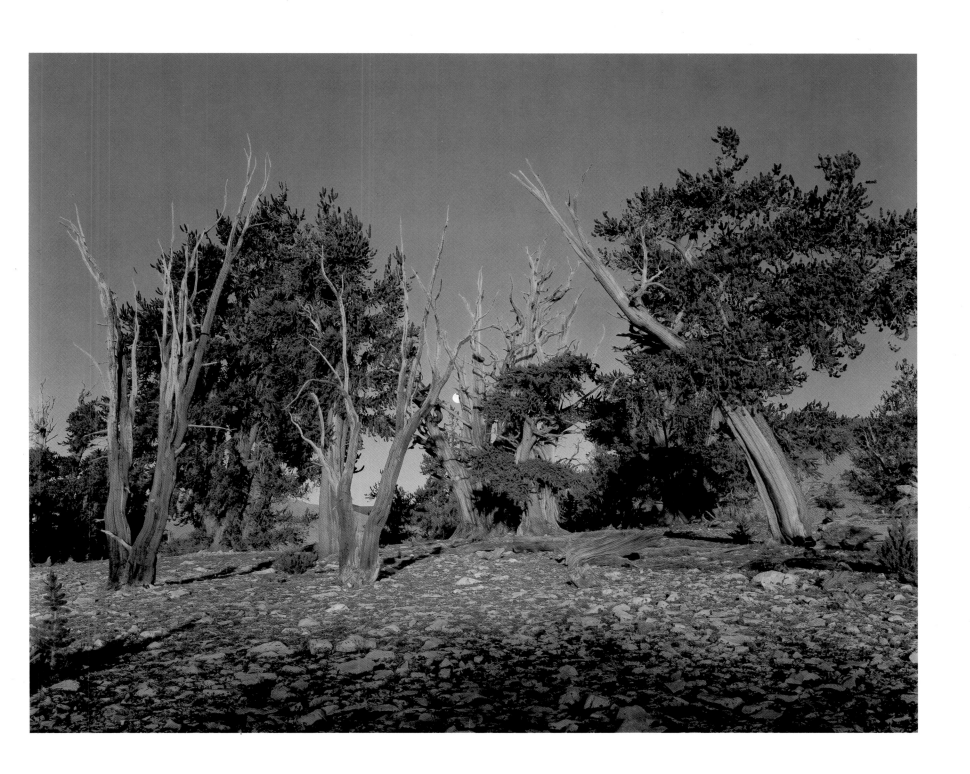

STORM

POINT LOBOS, CALIFORNIA

1977

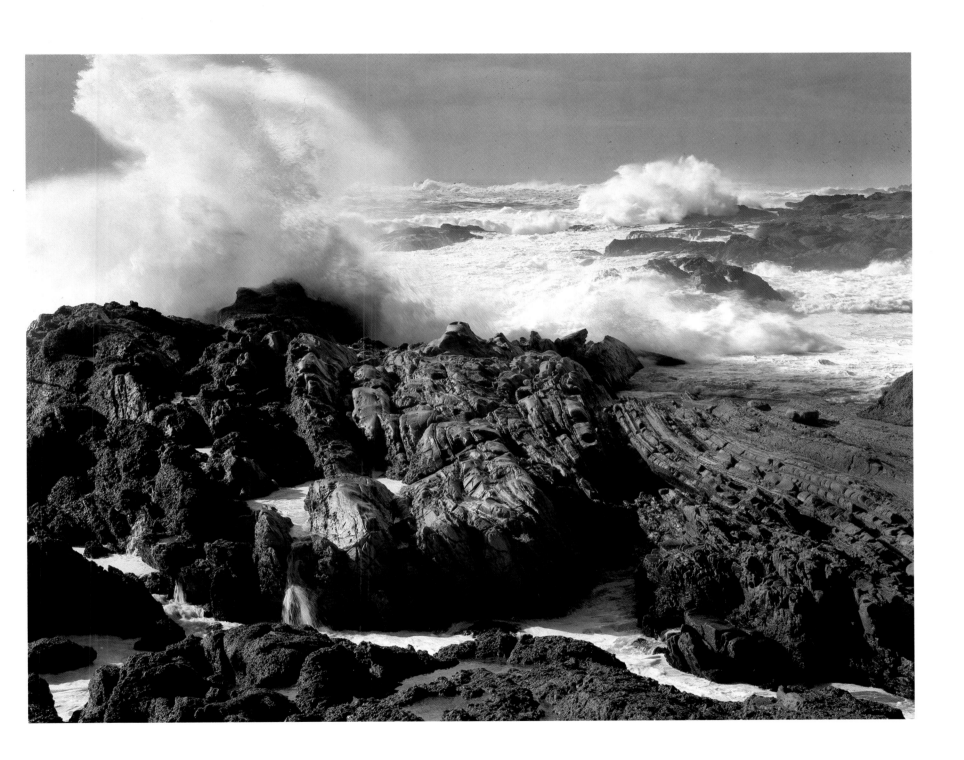

NUDE

CARMEL VALLEY

1978

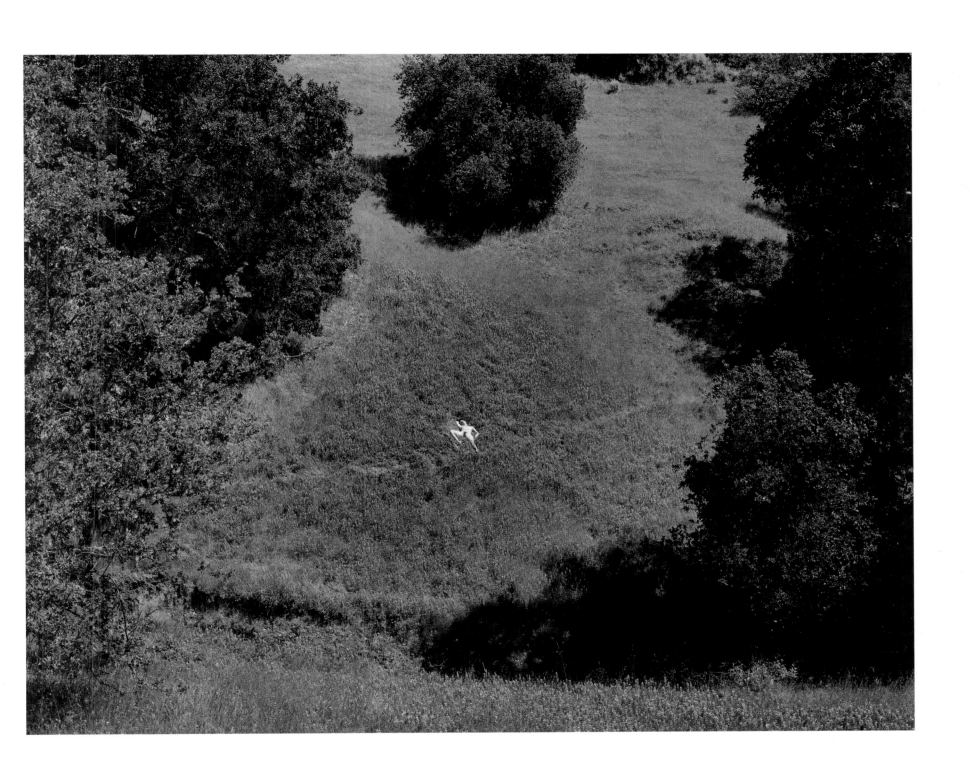

ASPENS

VICTOR, COLORADO

1980

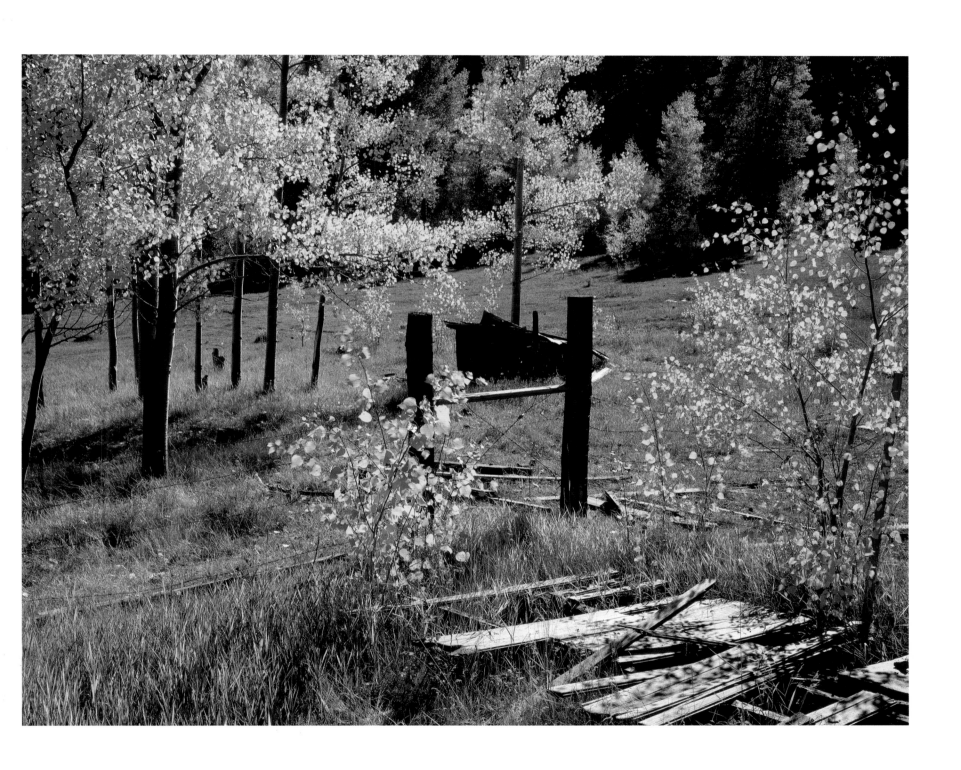

STUMP AND LEAVES

GARRAPATA

1980

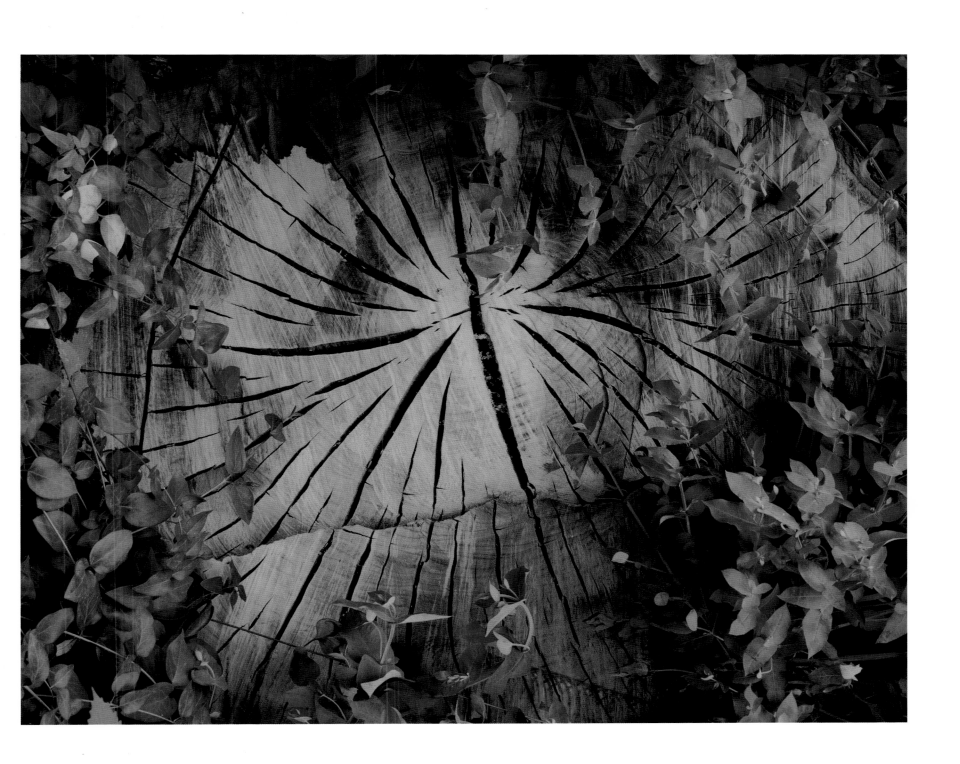

WATER TANK

ARIZONA

1980

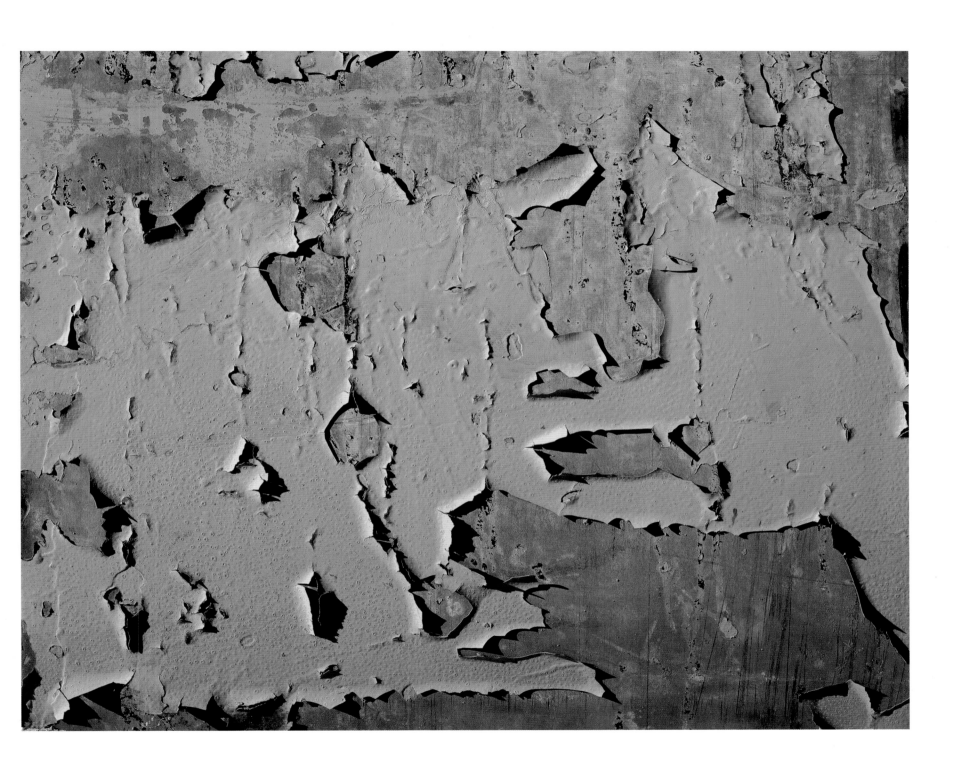

WRECKED AUTO

1981

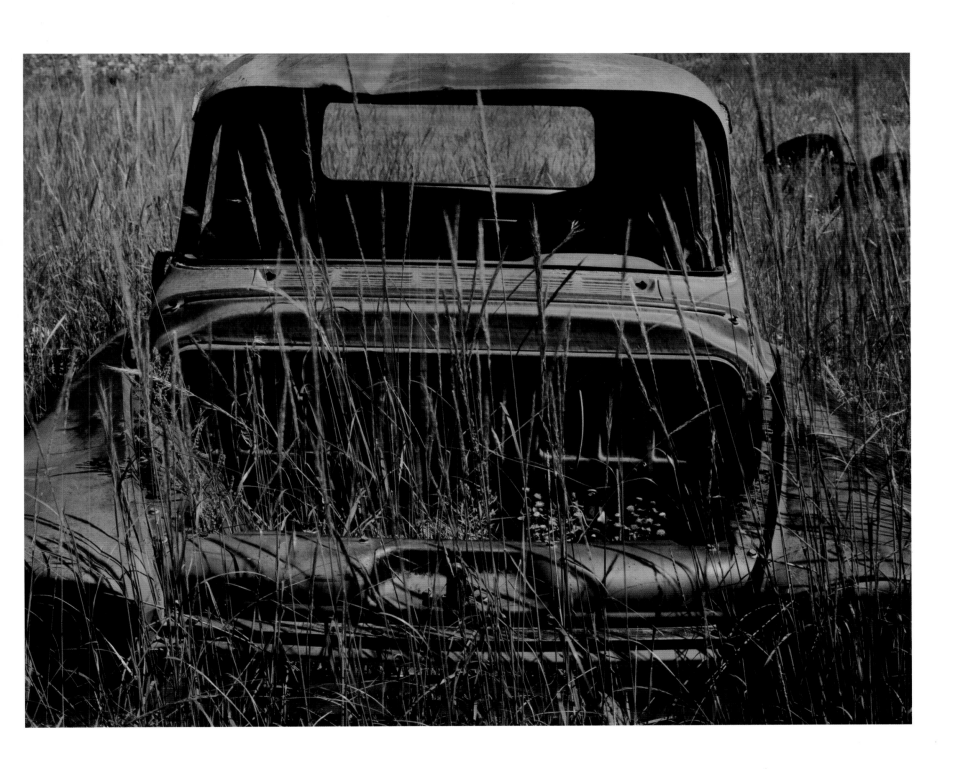

NUDE

DALLAS, TEXAS

1982

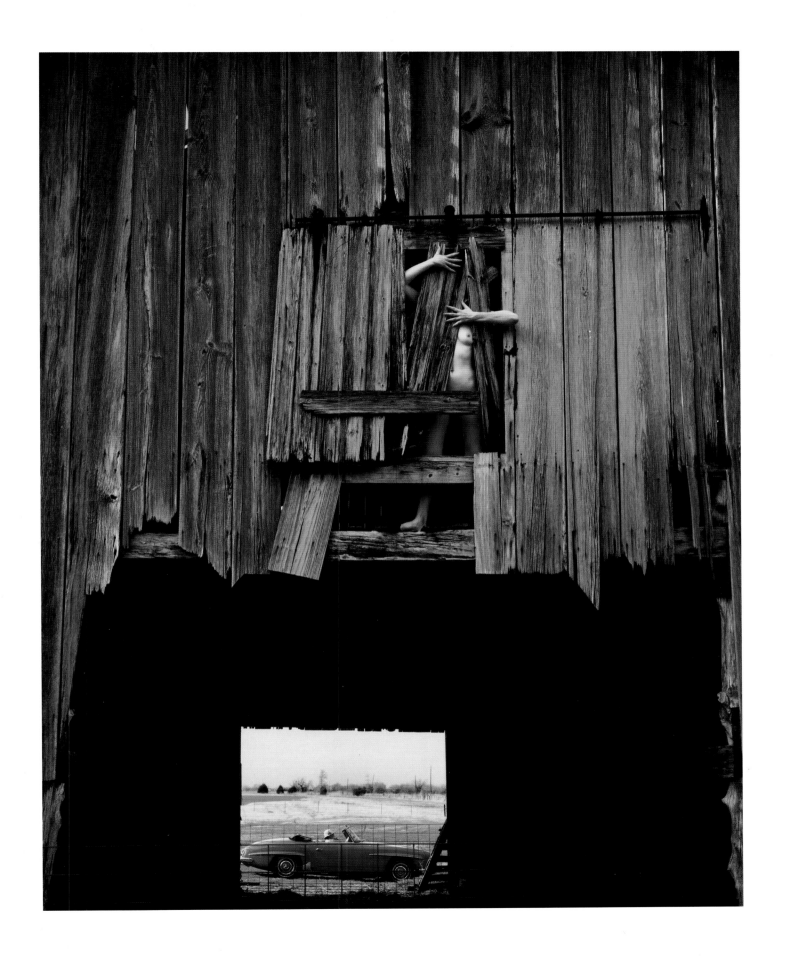

CHURCH

VLADIMIR, RUSSIA

1983

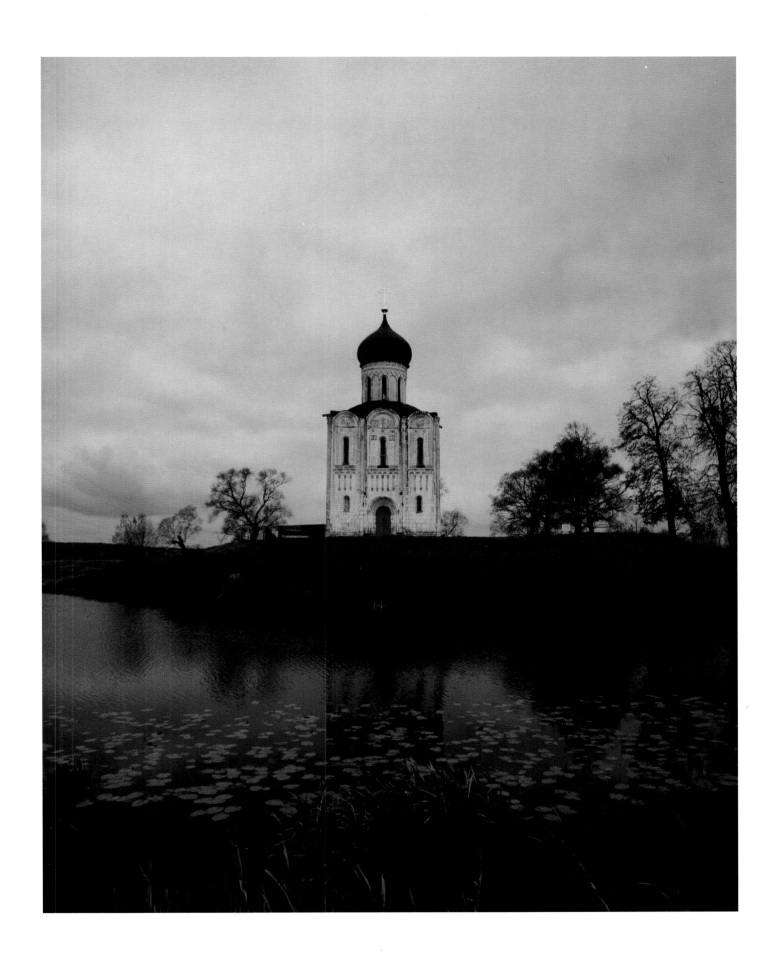

PUNTS

LES QUESNOY, FRANCE

1983

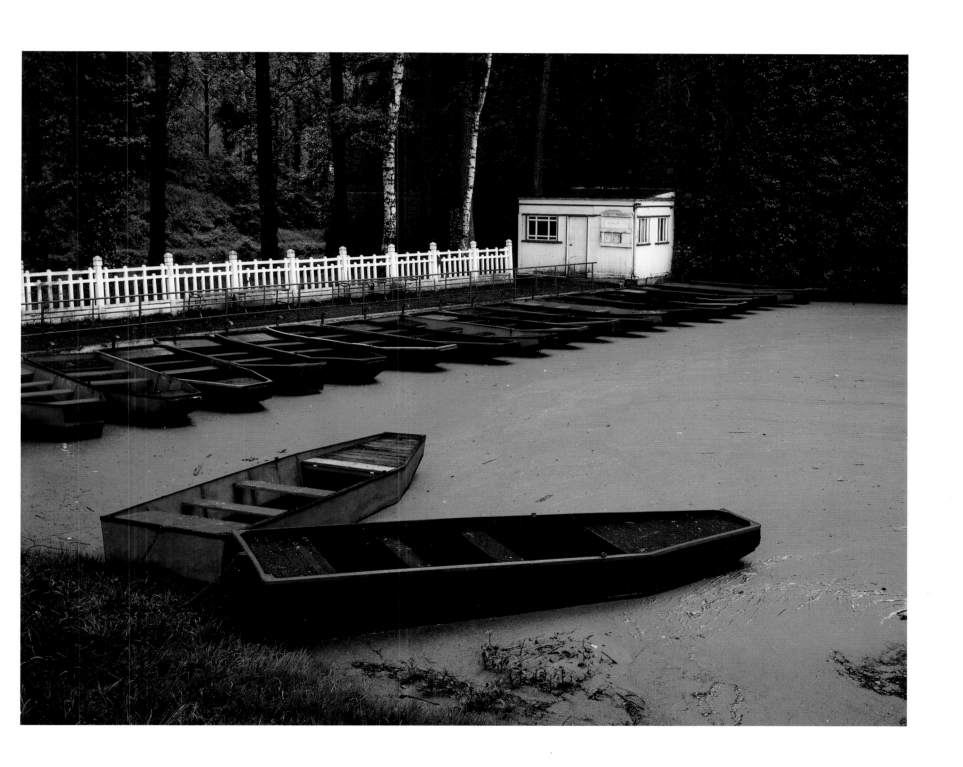

PUMP

ARLES, FRANCE

1983

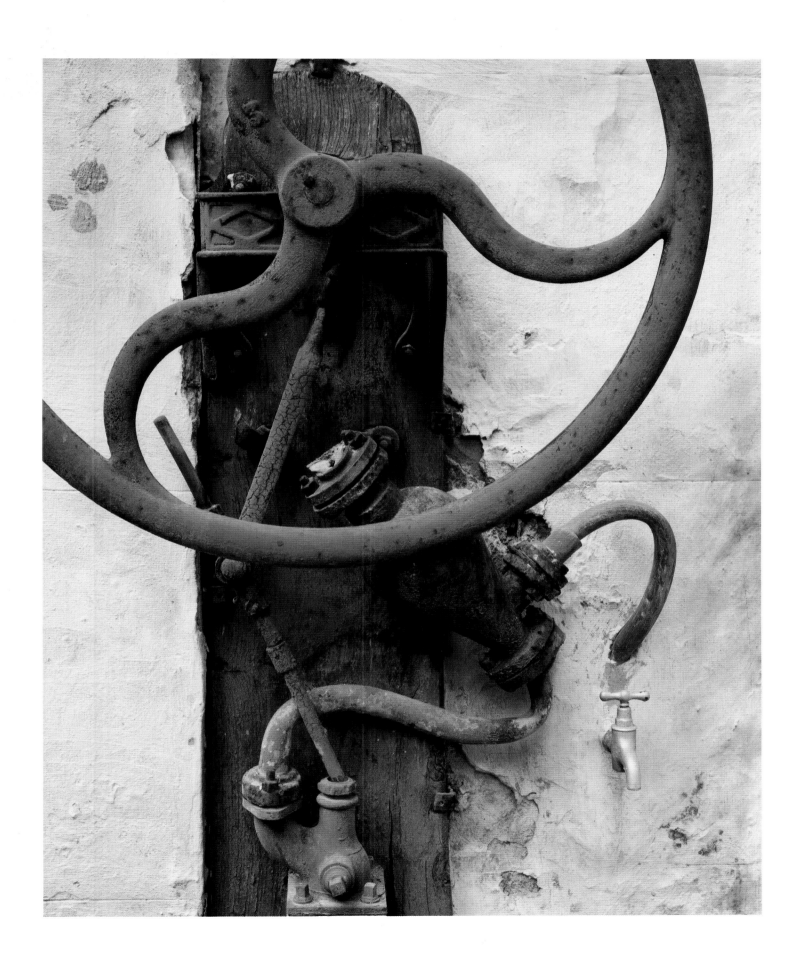

NUDE AND CLOISTER

FRANCE

1983

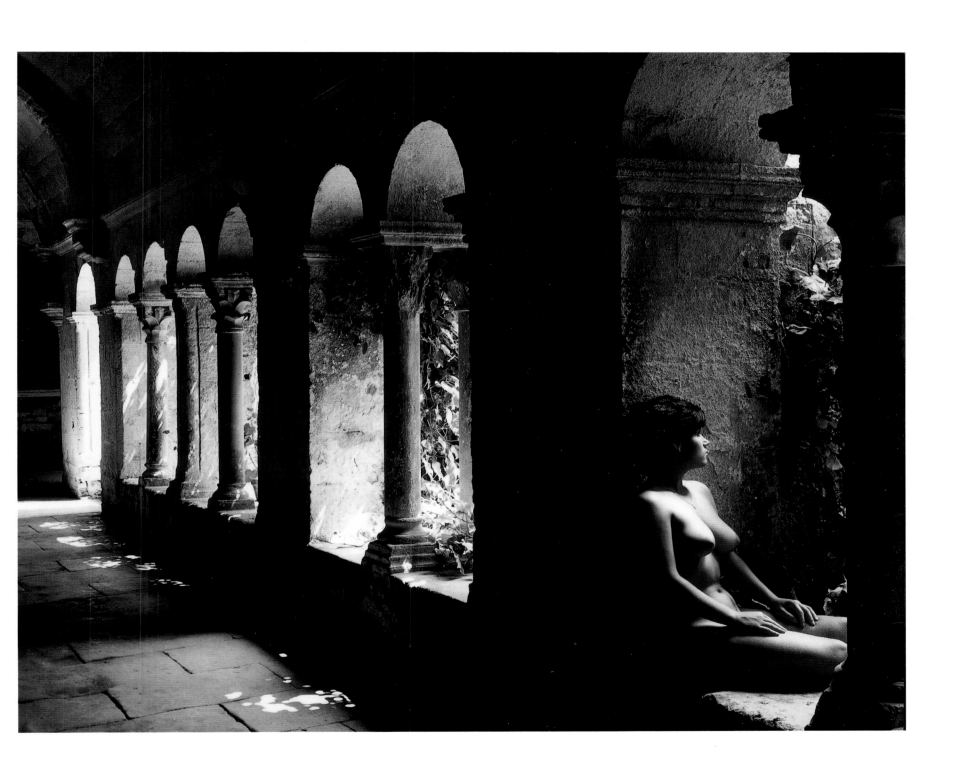

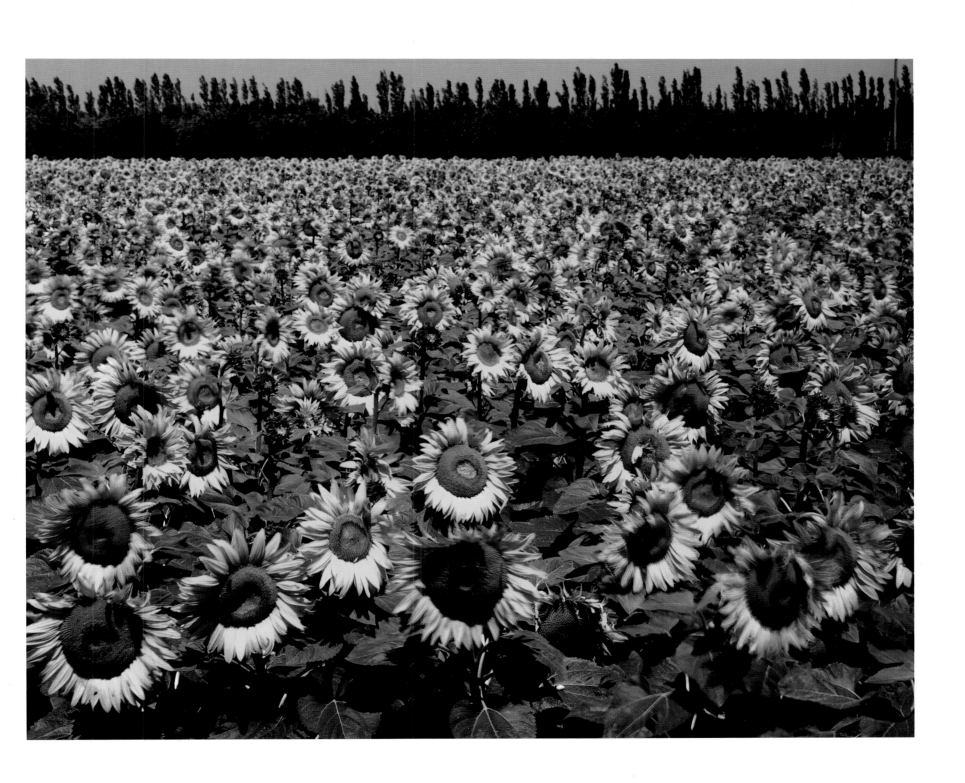

HAYFIELD

FRANCE

1983

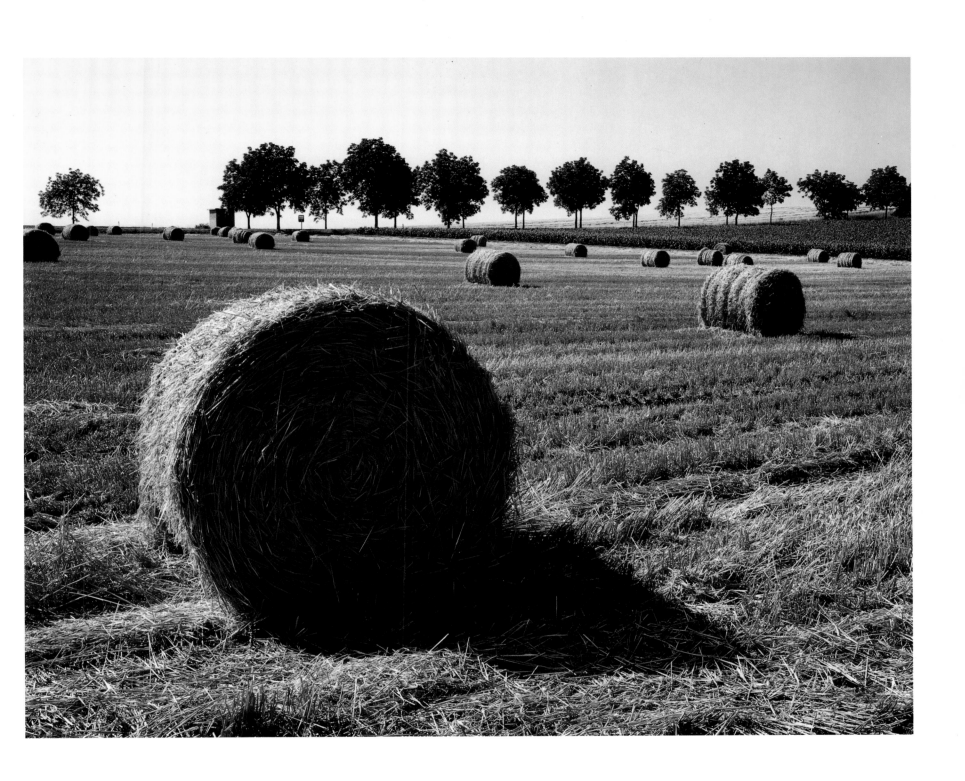

NUDE AND LAVA

HAWAII

1983

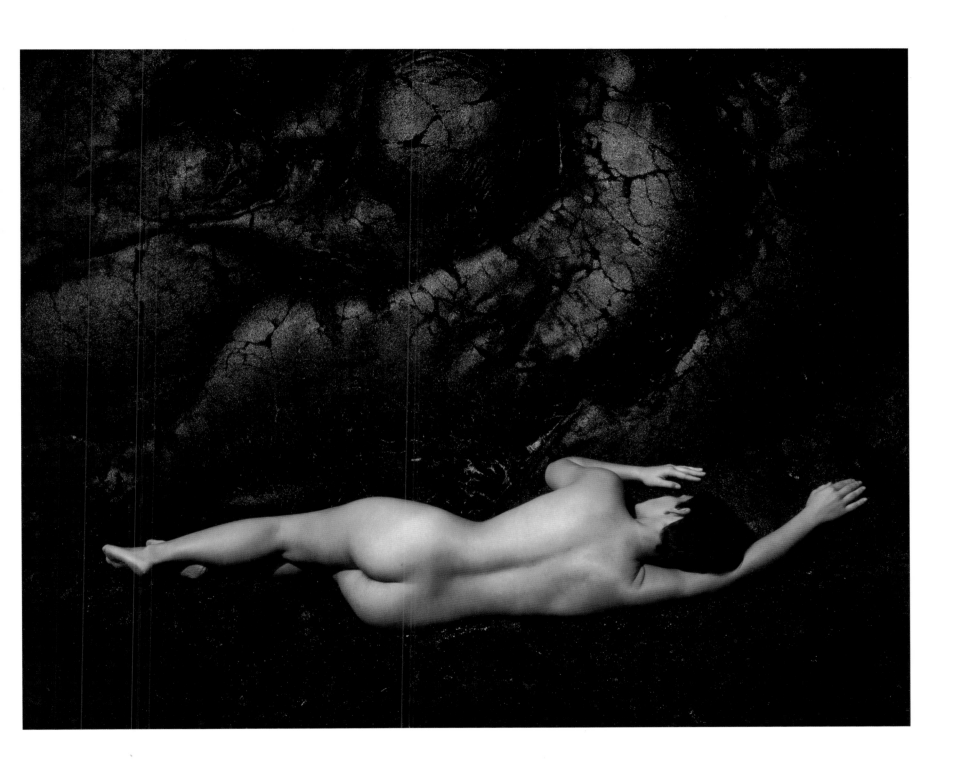

CACTI

HAWAII

1983

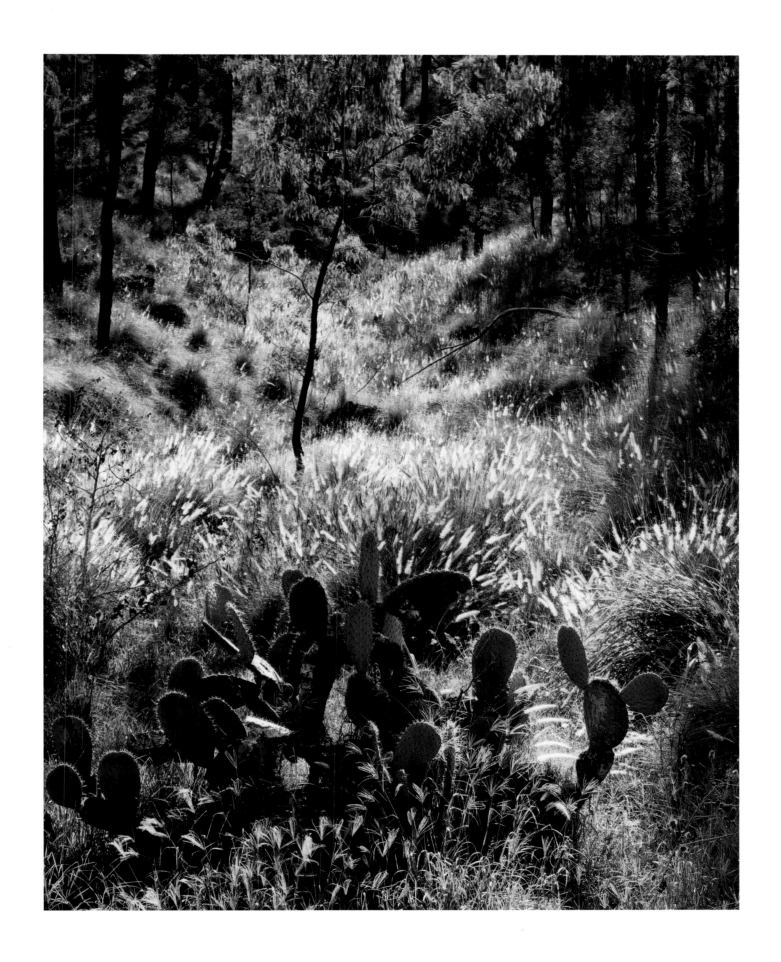

—

HORSE TRAILER

MONTANA

1984

—

LUCCA, ITALY

1984

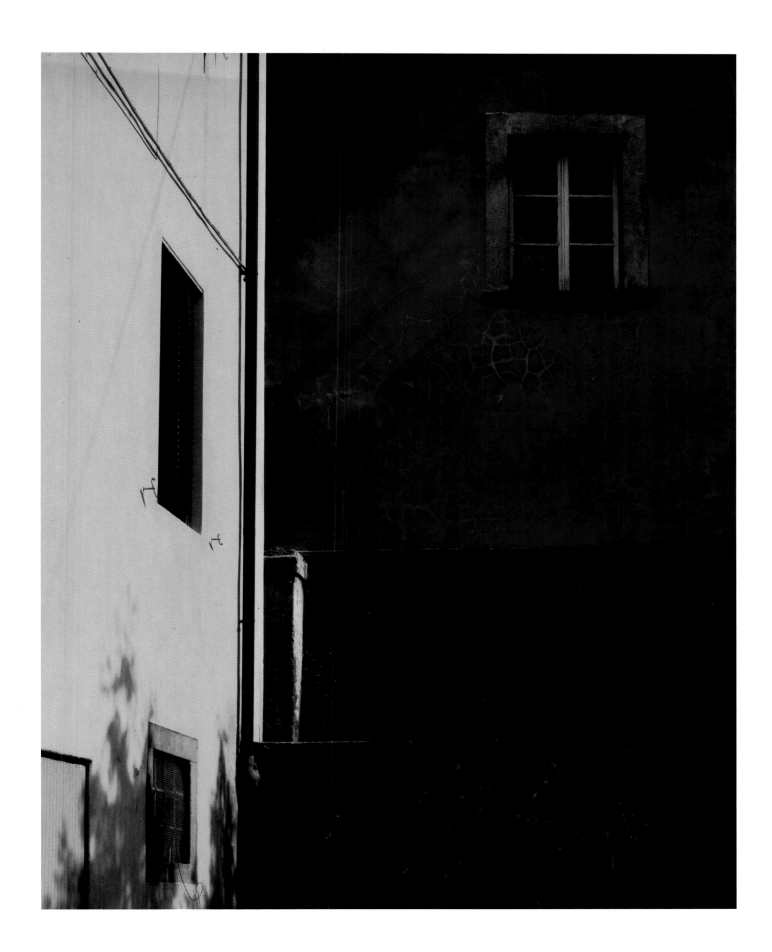

WAGON

1984

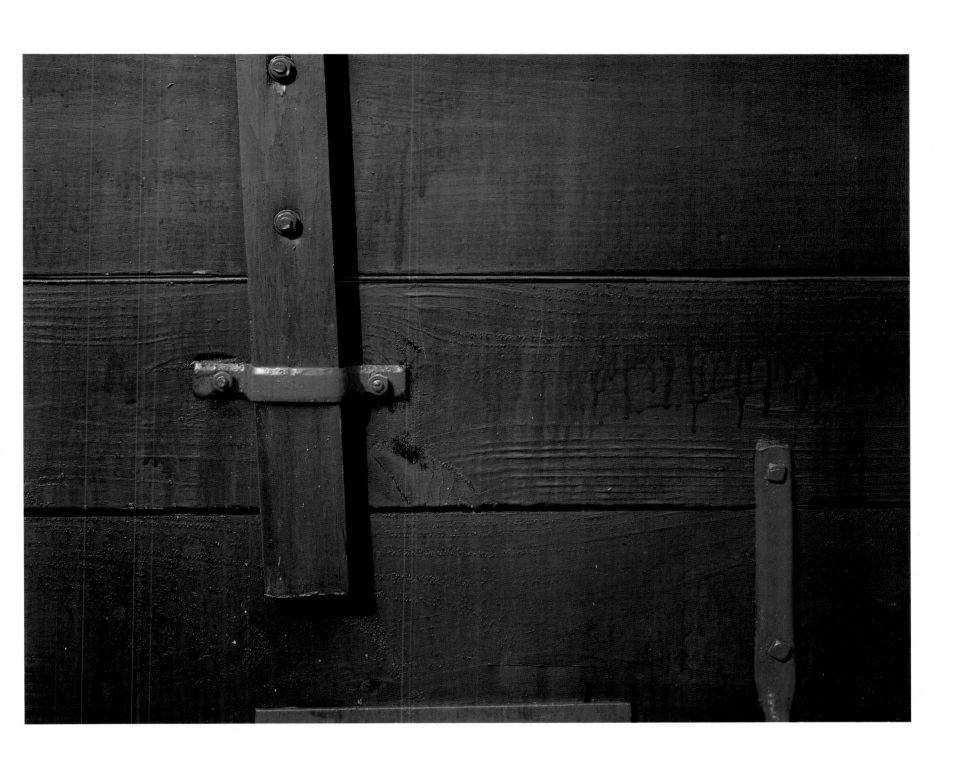

KELP

POINT LOBOS, CALIFORNIA

1985

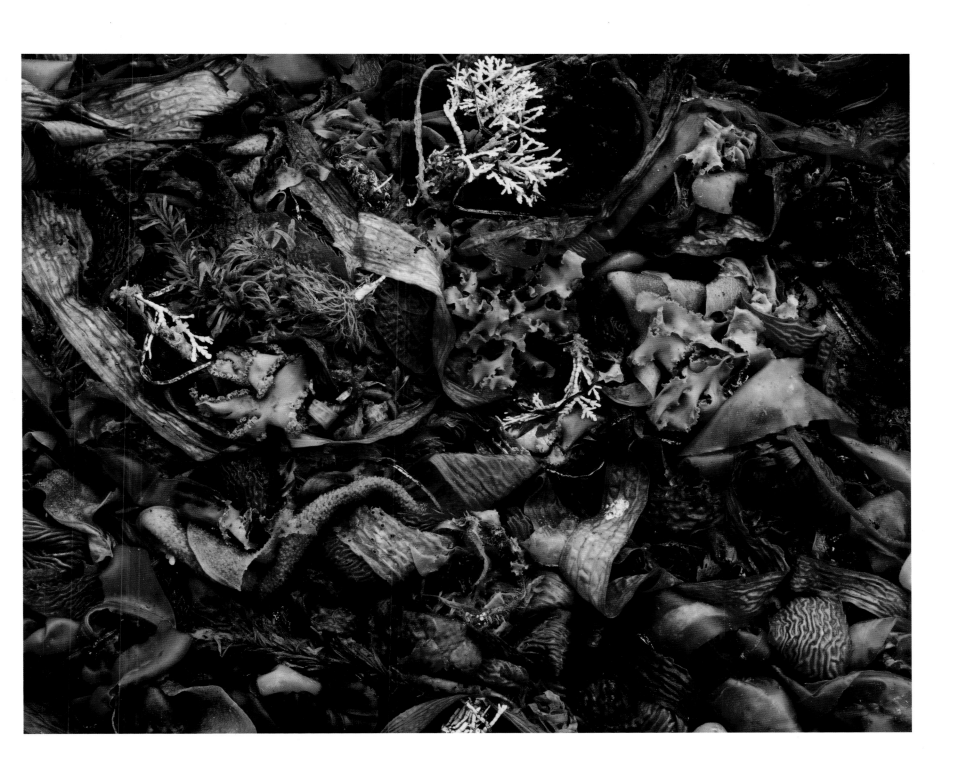

TAR

NORTH CAROLINA

1985

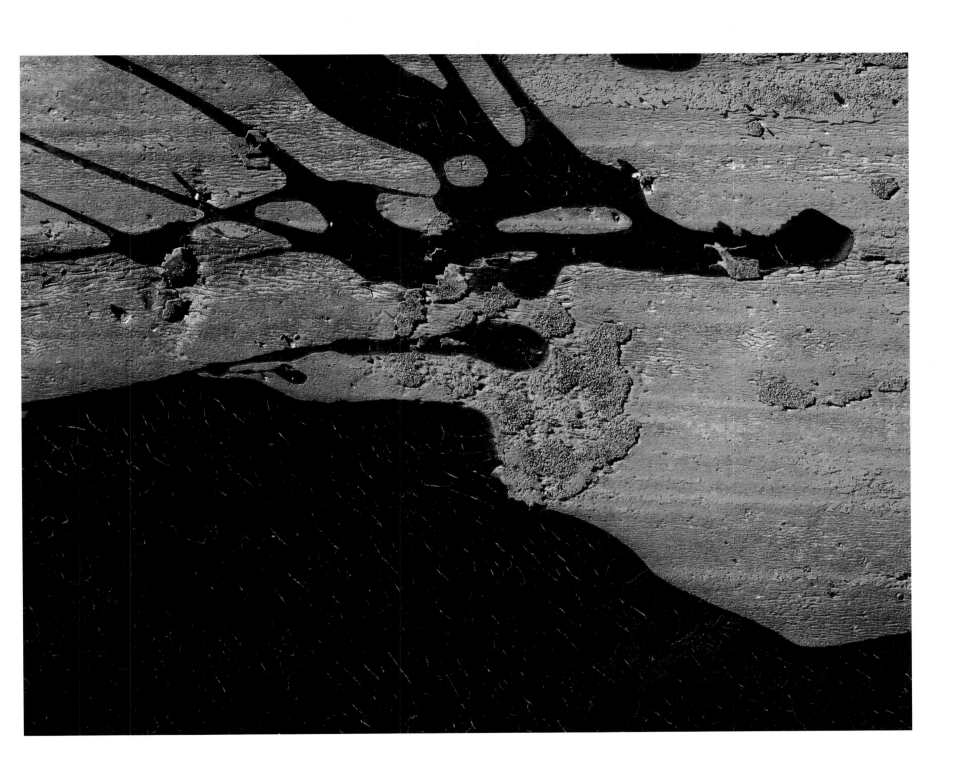

———

ERODED ROCK

BEAN HOLLOW BEACH, CALIFORNIA

1986

———

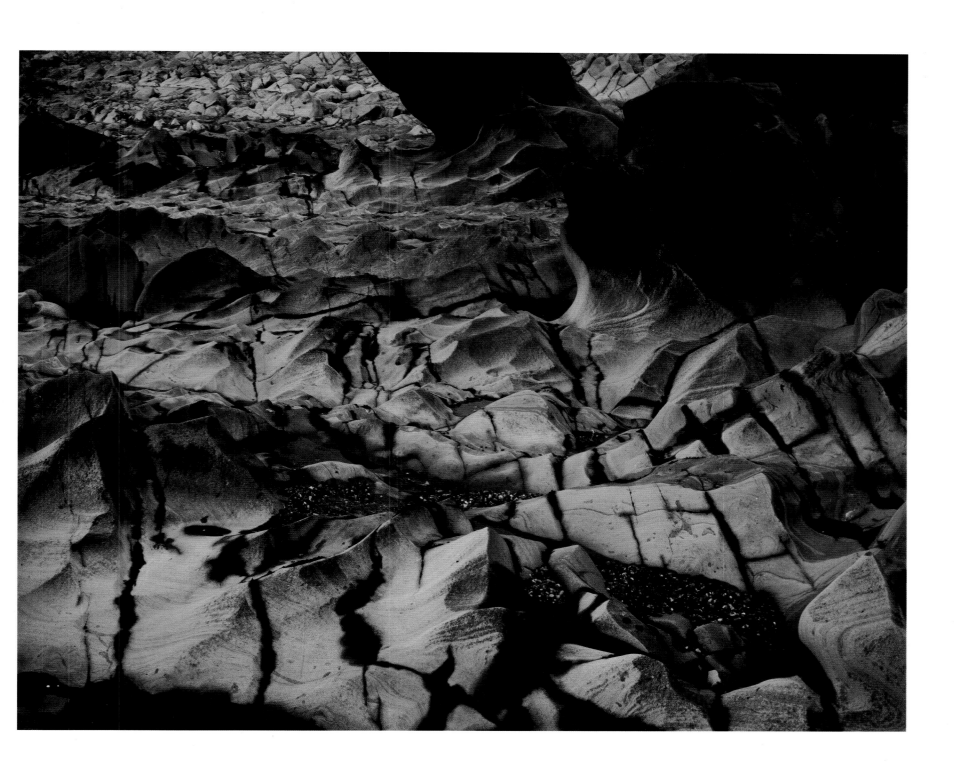

COMBINE

MISSOURI

1987

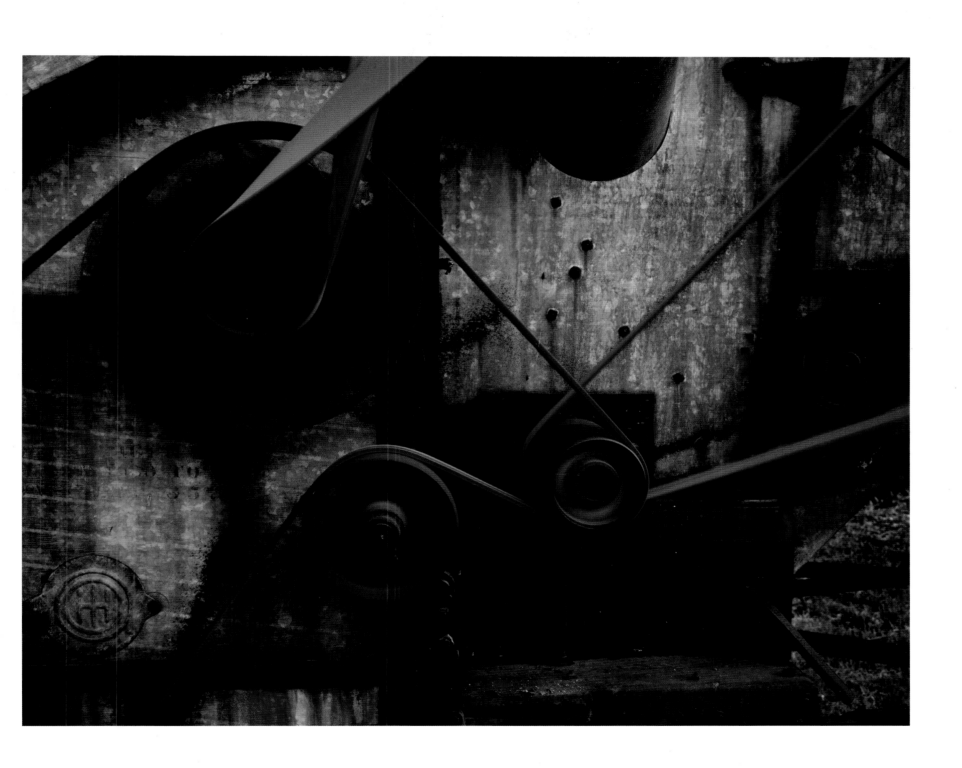

ABANDONED CAR

VICTORIA

1987

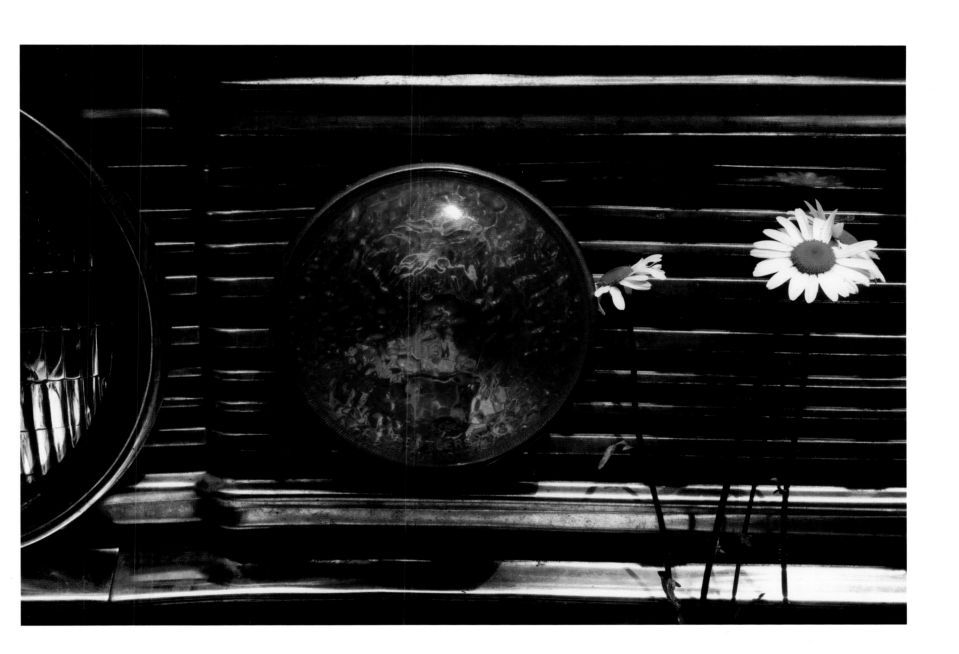

NUDE

GARRAPATA

1987

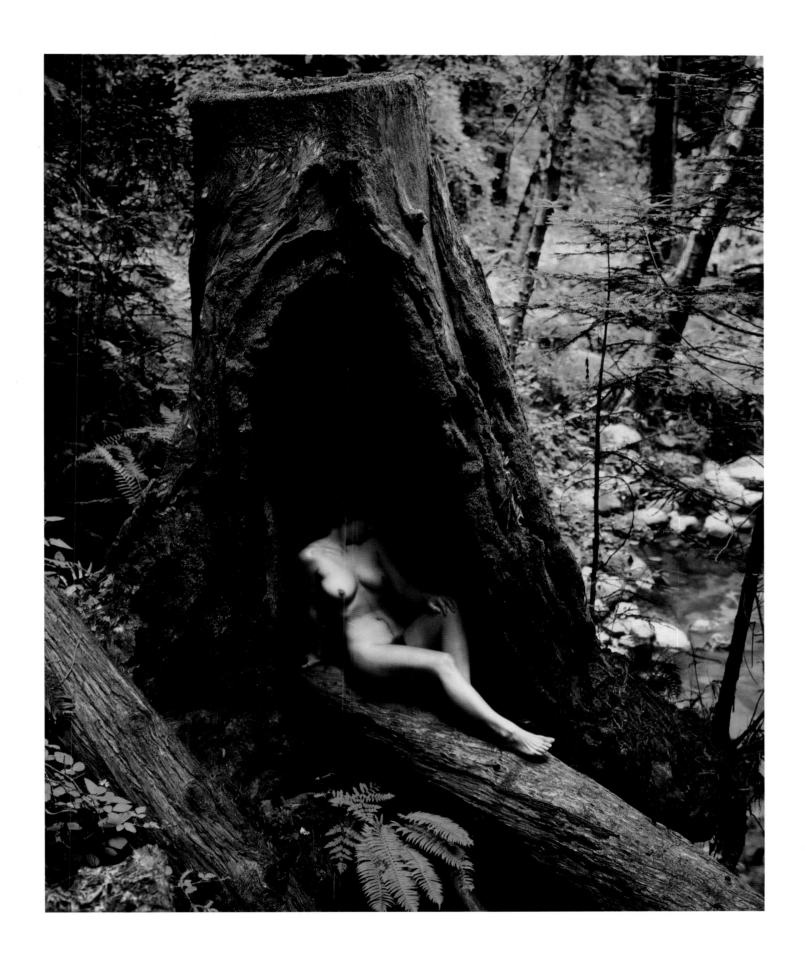

NUDE

HAWAII

1988

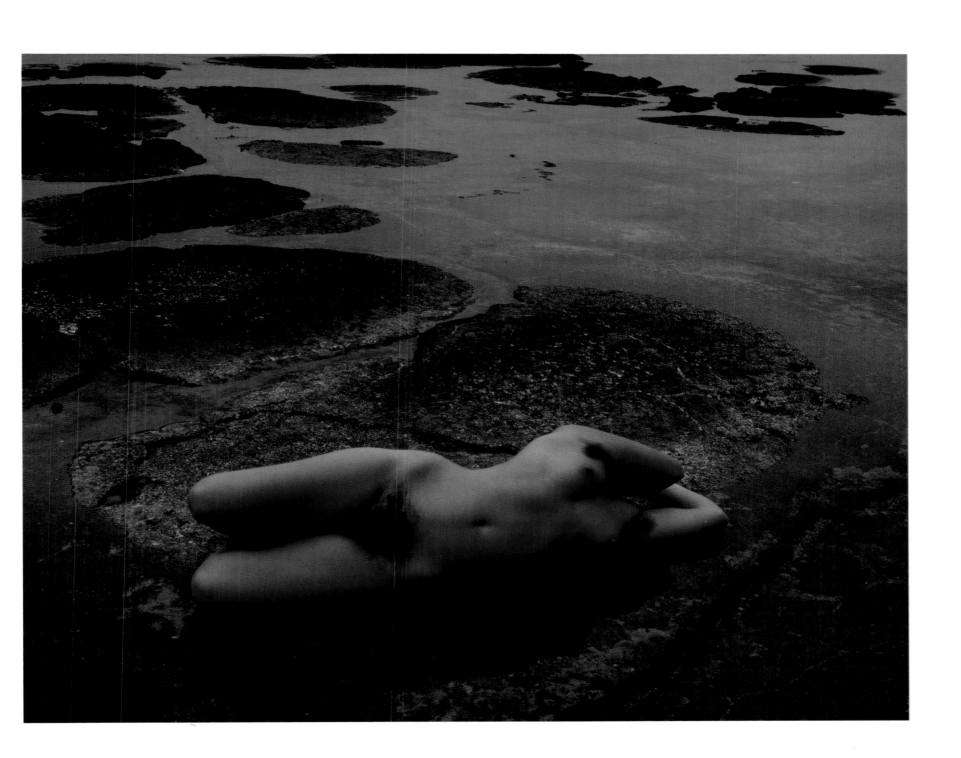

―――

BARK

HAWAII

1988

―――

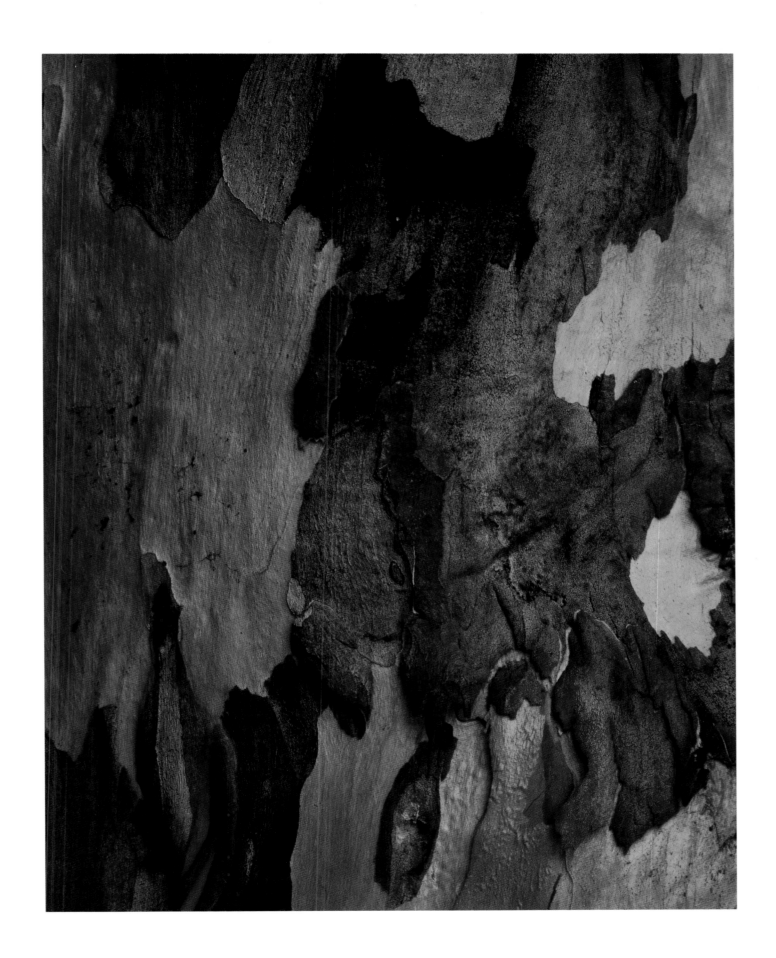

NUDE

UTAH

1989

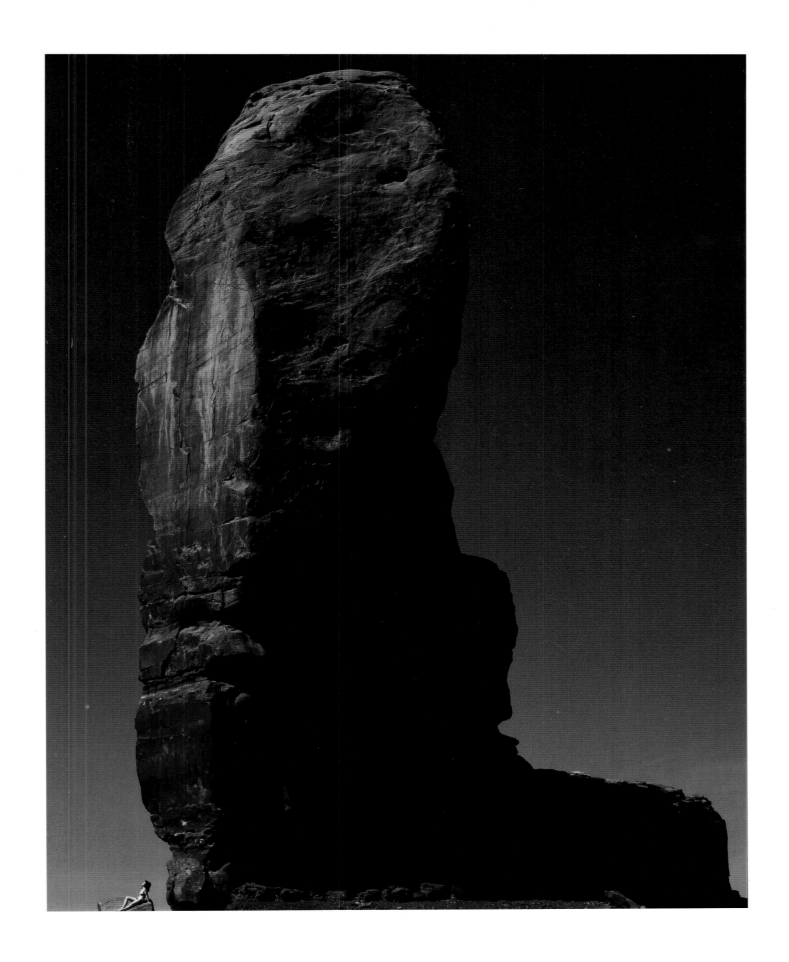

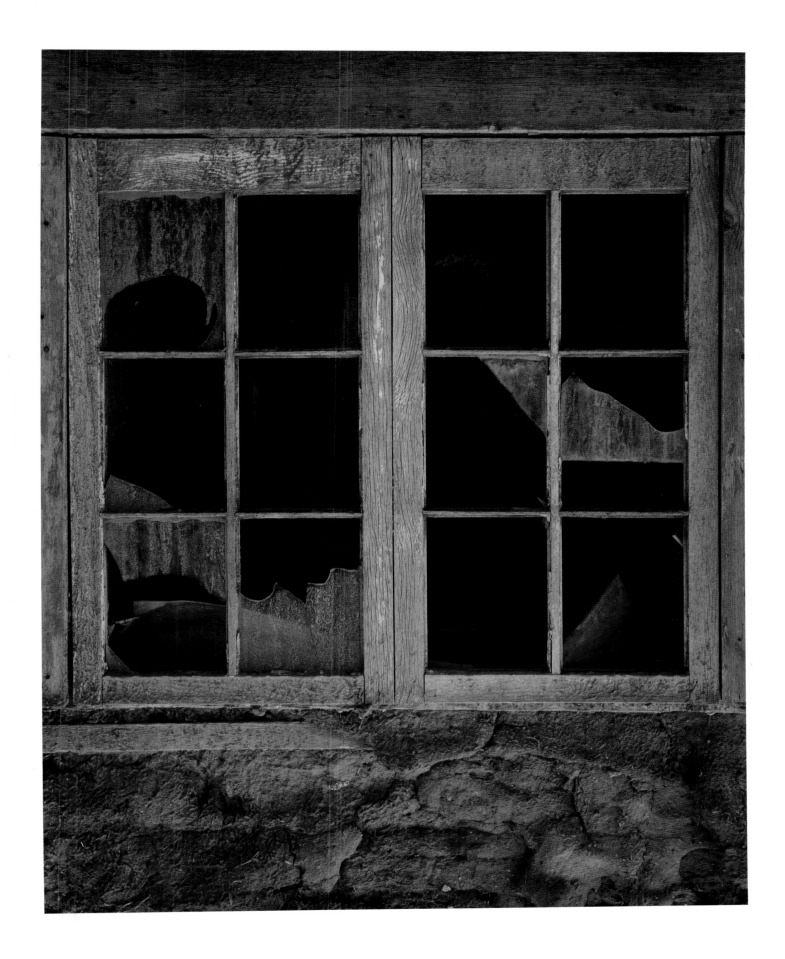

WALL

CHIMAYO

1989

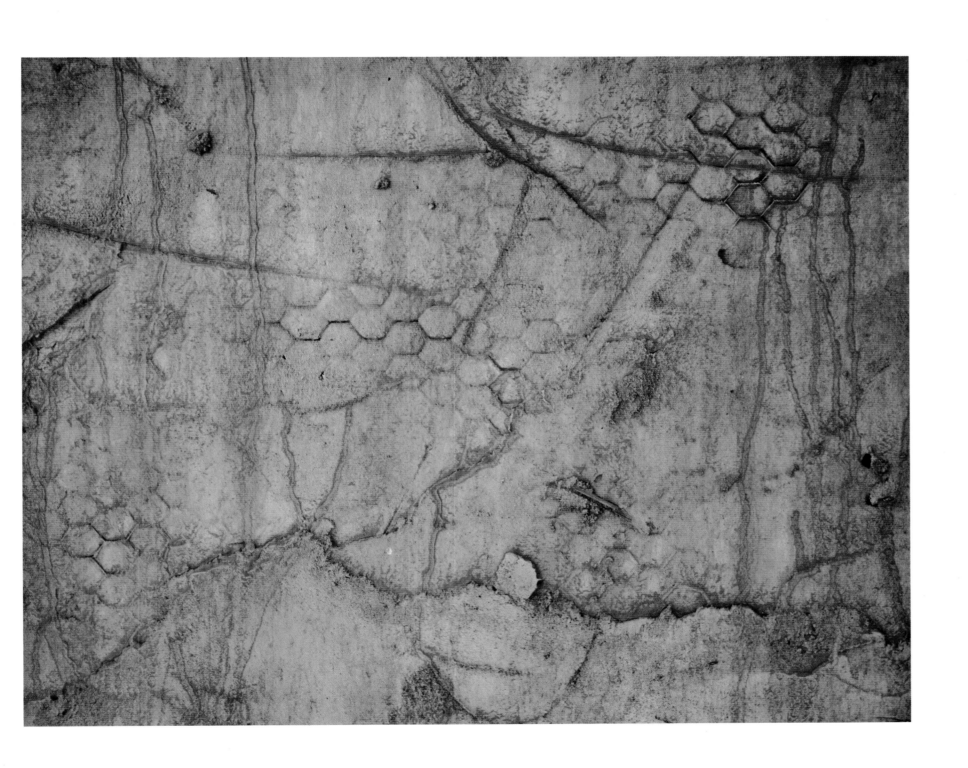

GRADER

NEW MEXICO

1989

———

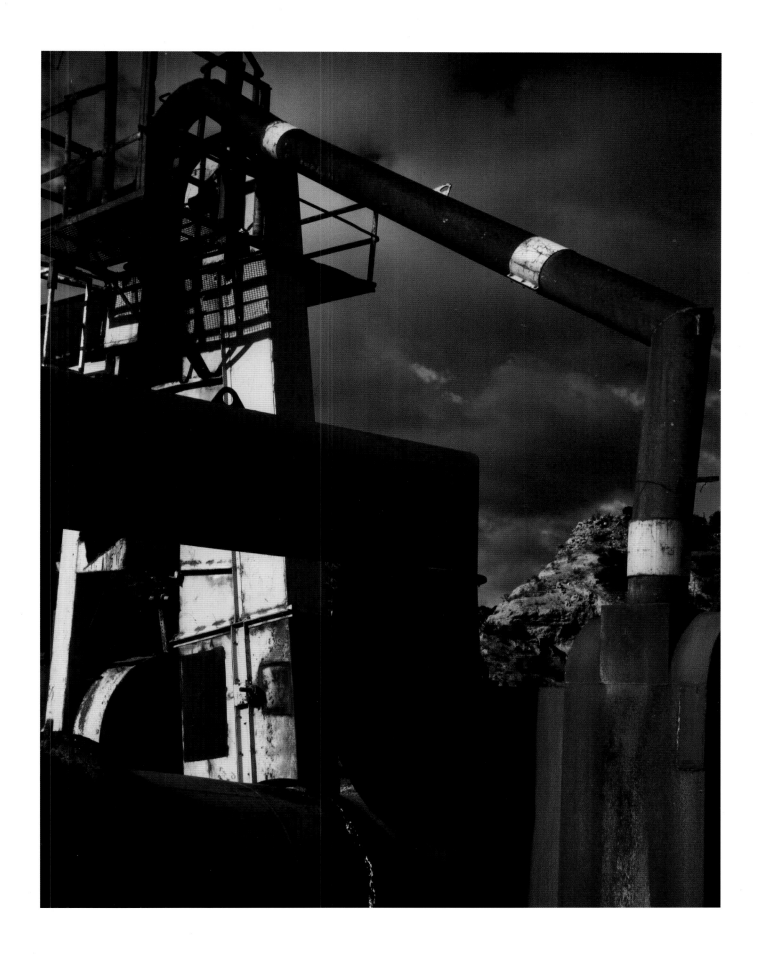

—

CABBAGE

1989

—

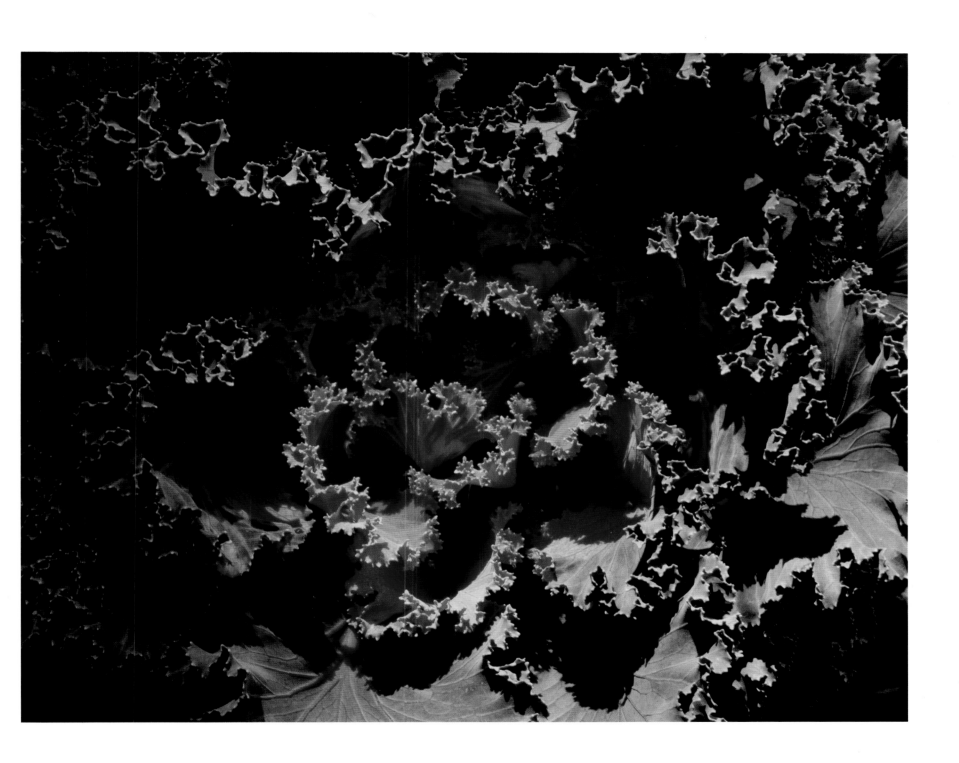

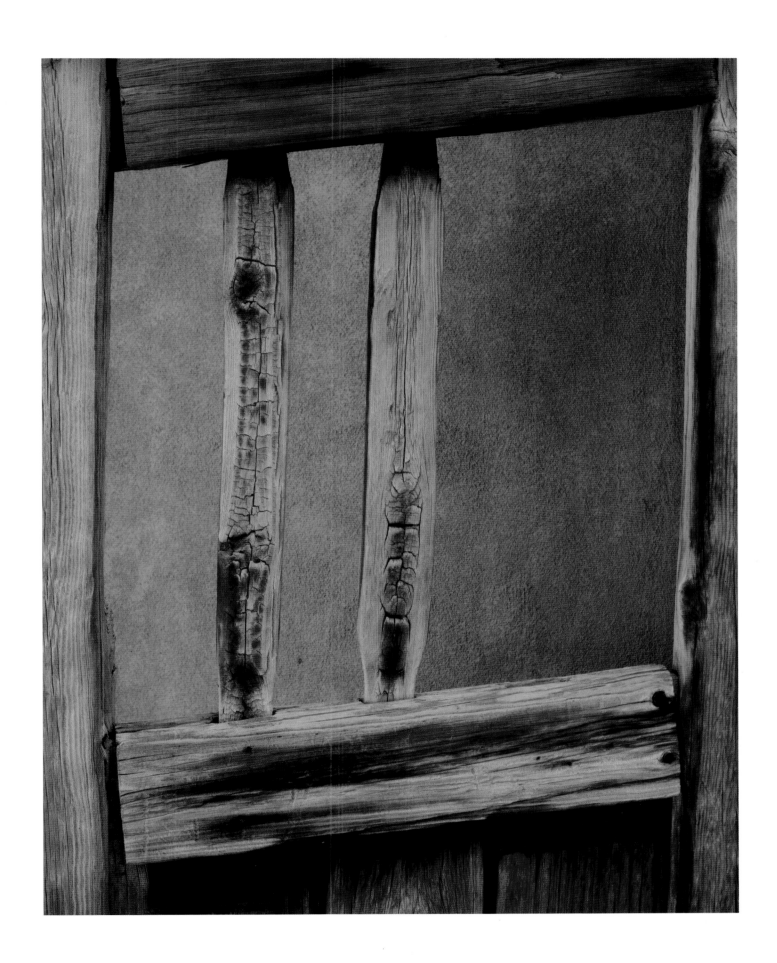

DUNES

OCEANO, CALIFORNIA

1990

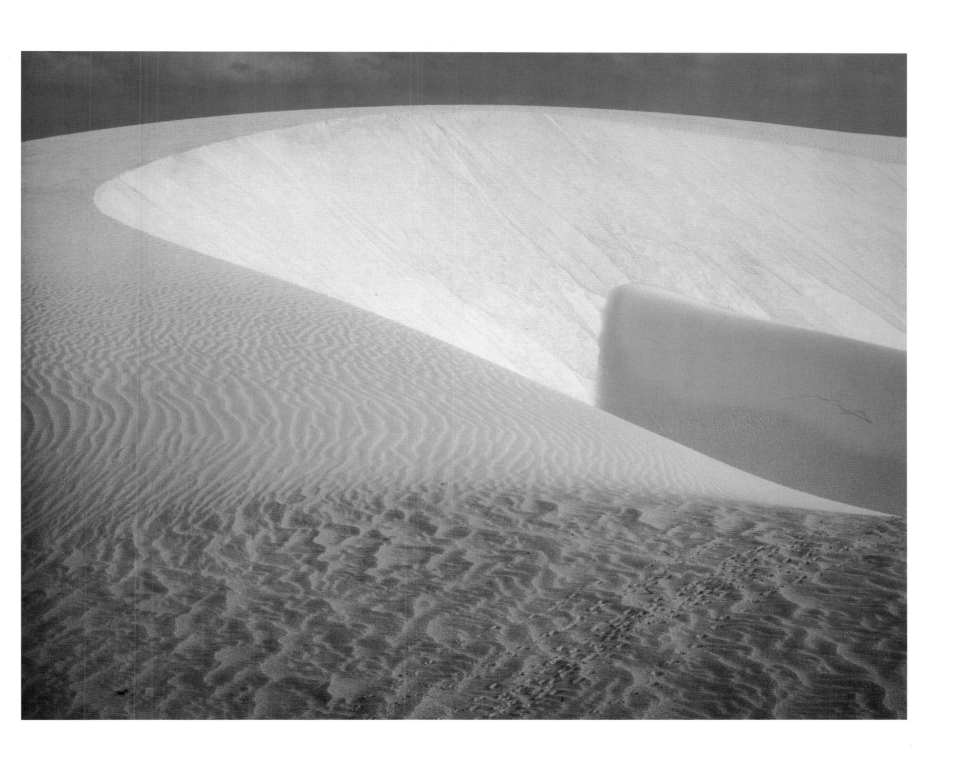

DUNE TRACKS

OCEANO, CALIFORNIA

1990

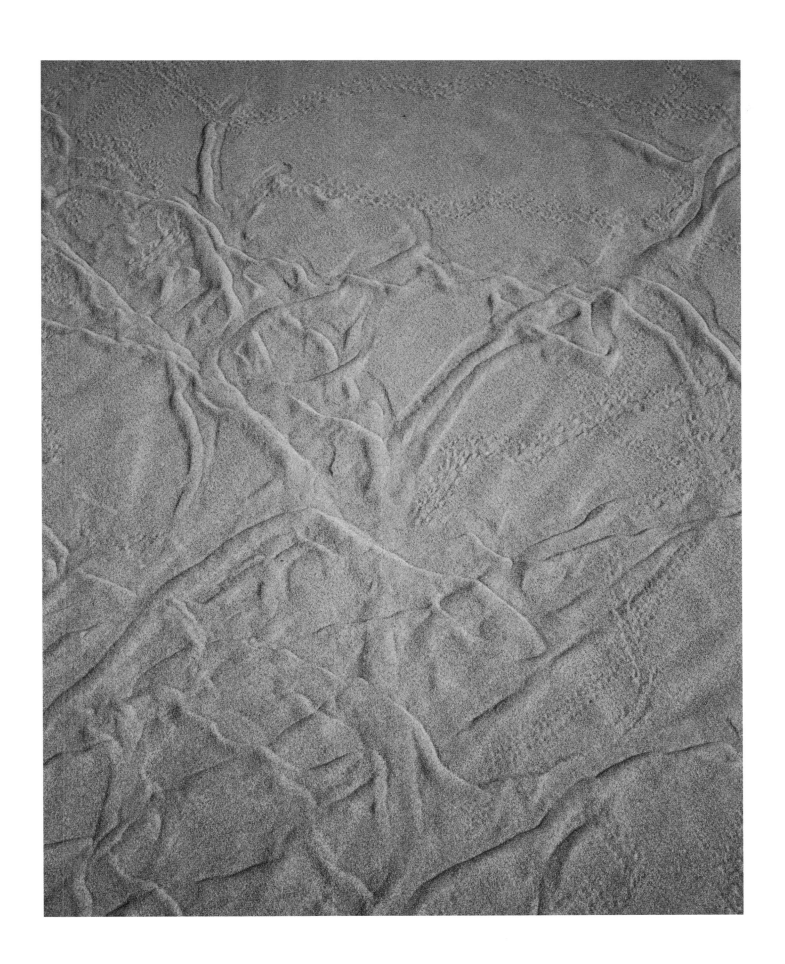

FERN

GARRAPATA

1990

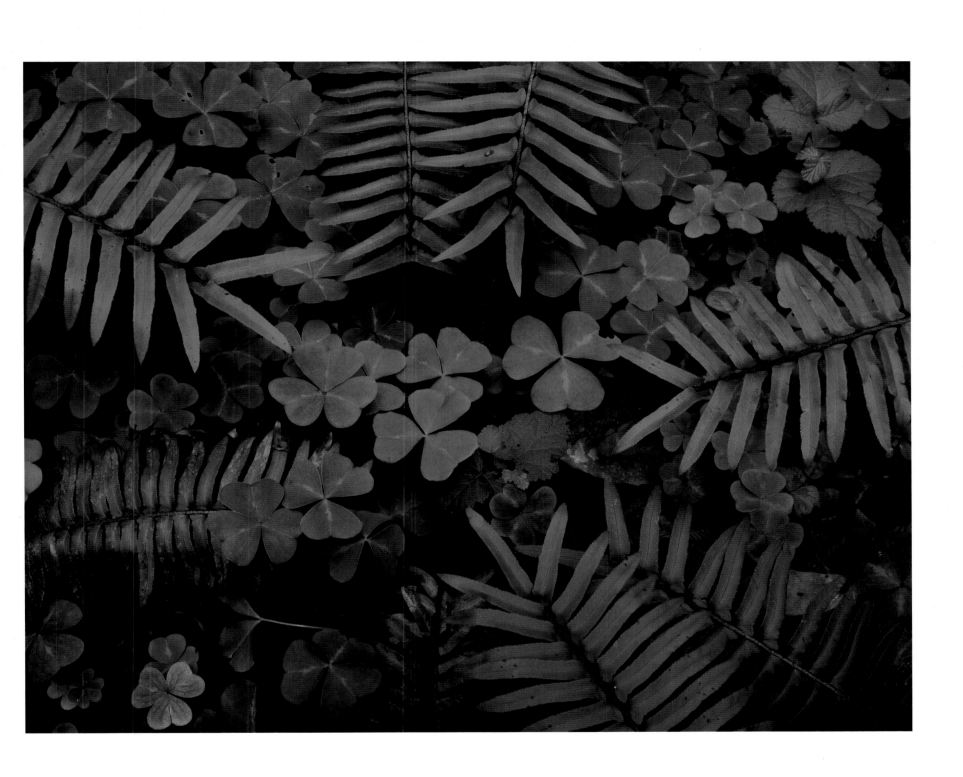

GRAVEYARD

CANADA

1990

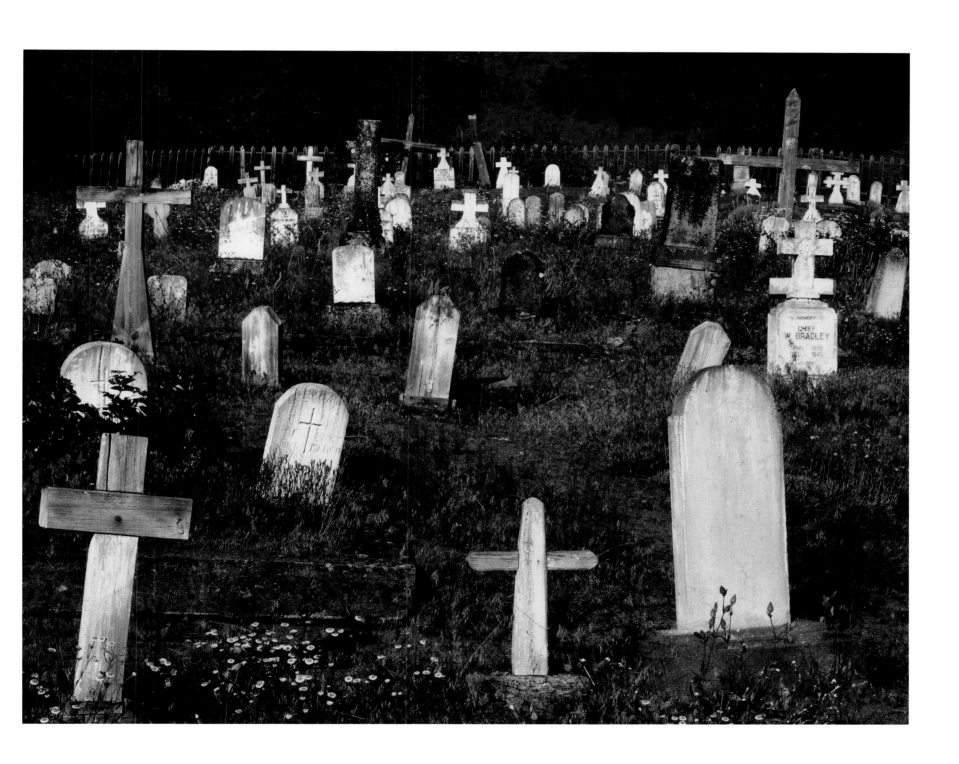

─────

HAY

ALBERTA

1990

─────

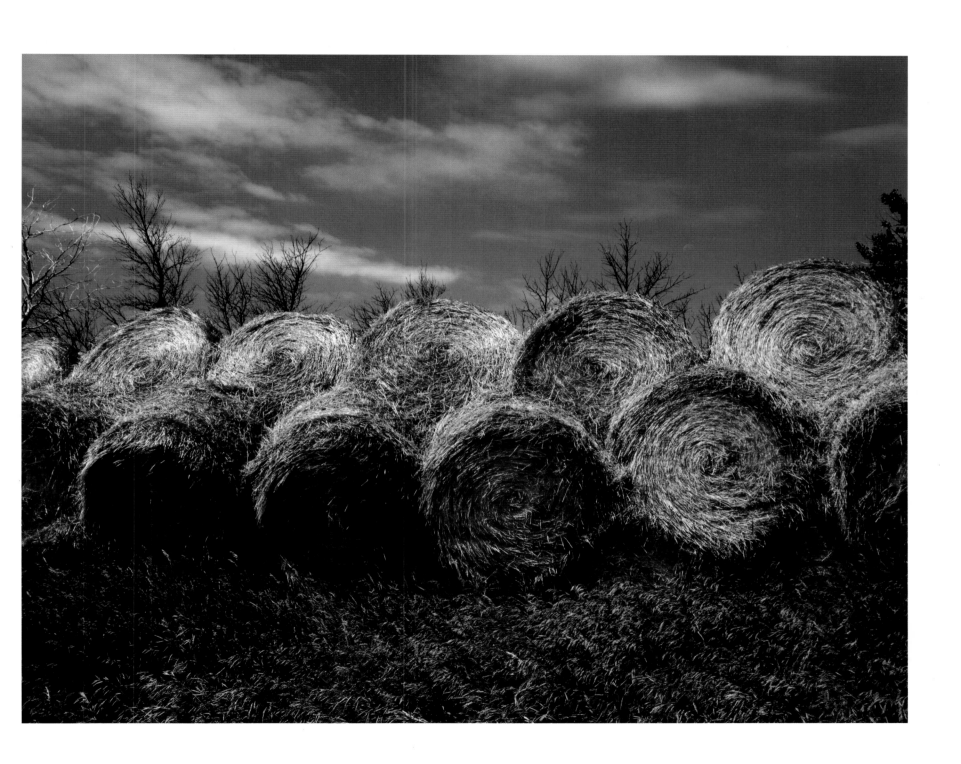

SKULLS AND FLOWERS

COLORADO

1990

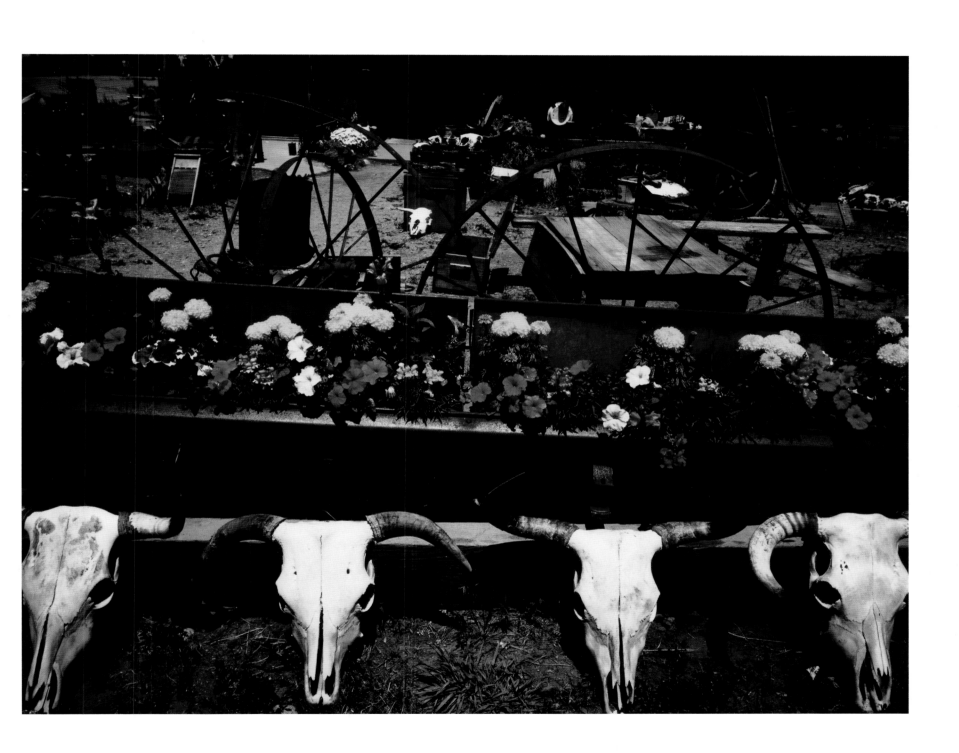

INSULATORS

COLORADO

1990

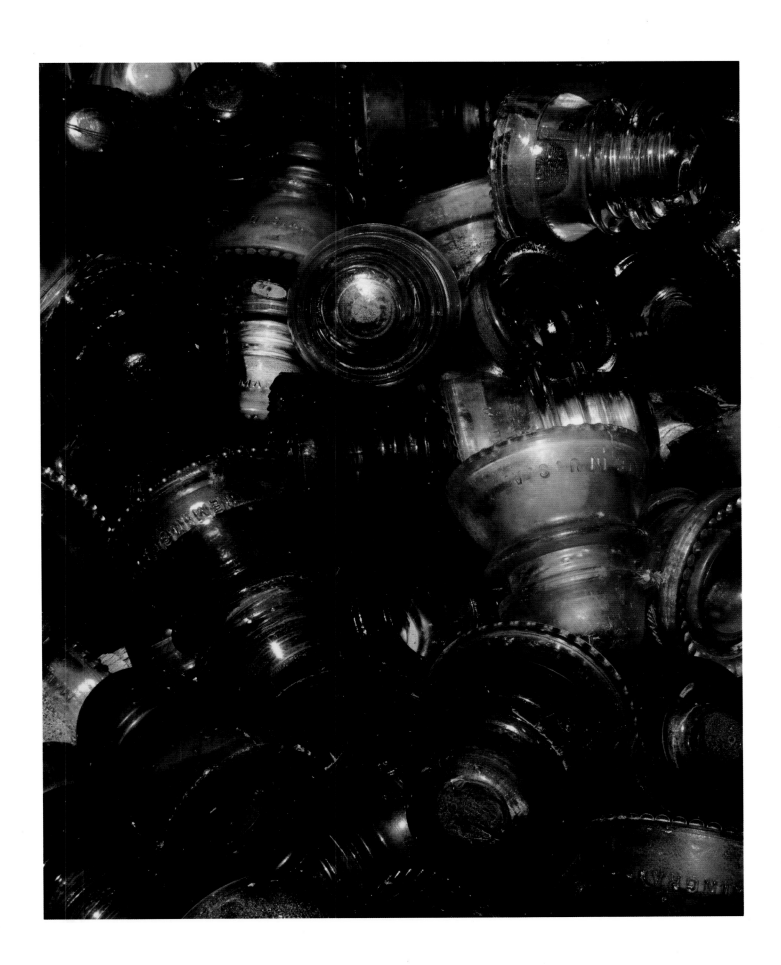

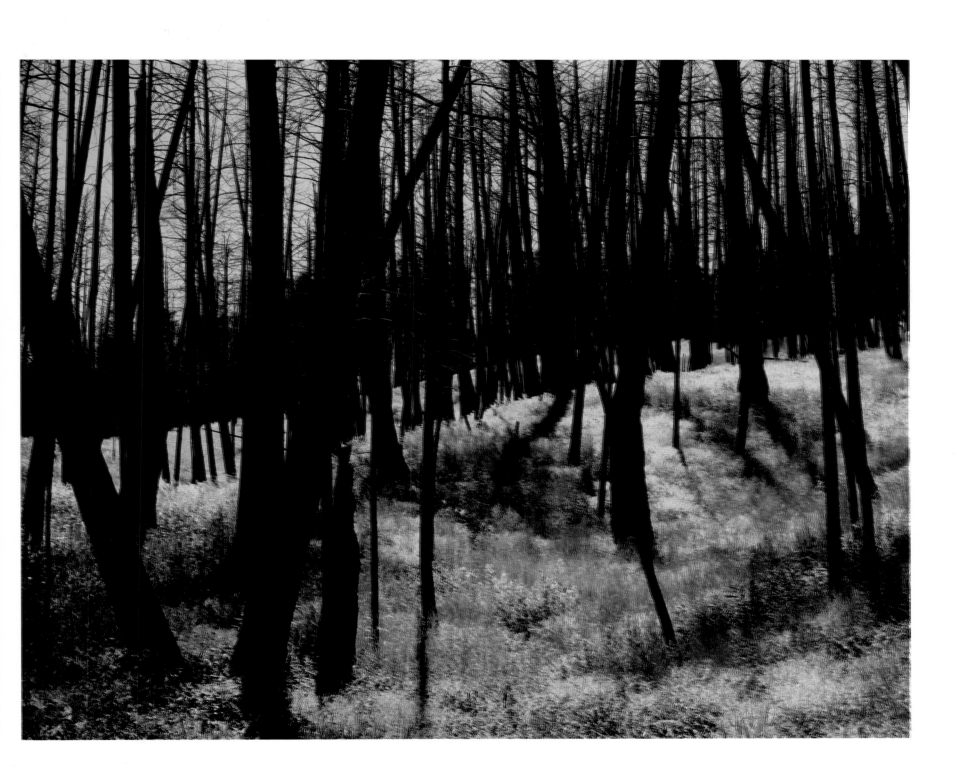

EROSION

POINT LOBOS

1990

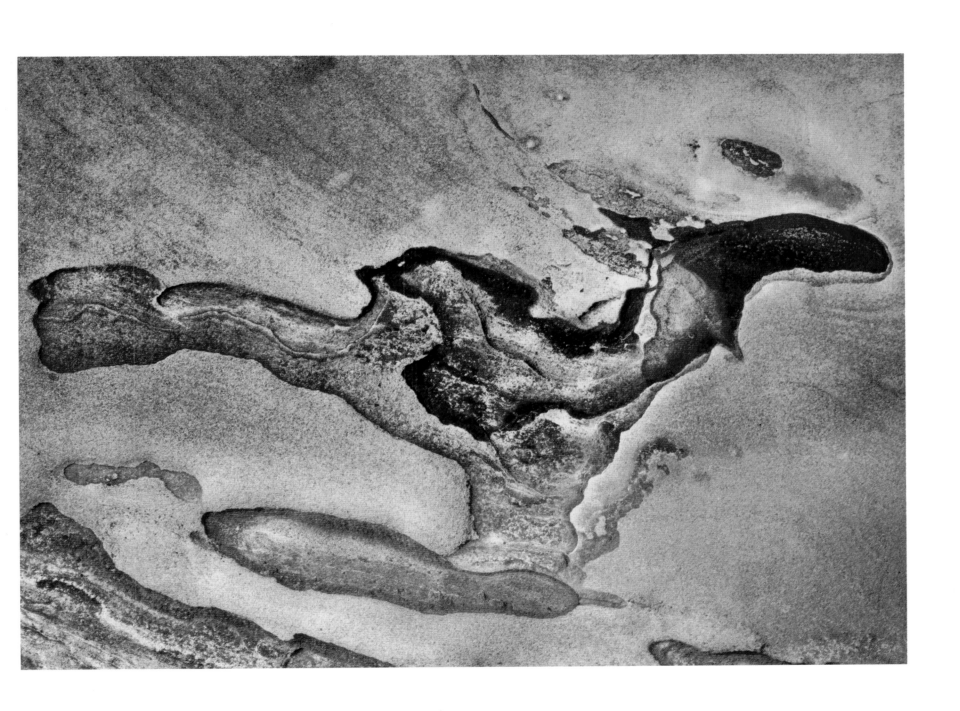

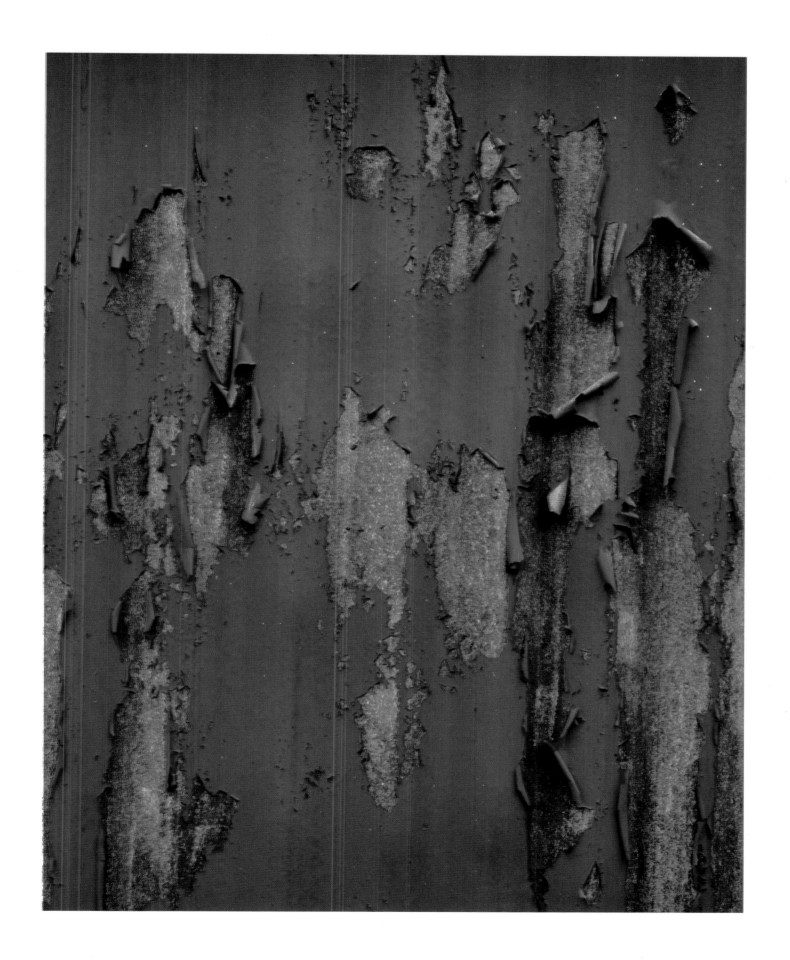

AFTERWORD

I have only one medicine to prescribe…an interest in living…it may be metropolitan or rural, poetic or realistic; but it must be genuine and exceptional. Unless he has this interest, this intelligent curiosity and relish for life, he will never be an artist.

Thomas Craven

That prescription, intended for painters but salubrious for any artist, was written sixty years ago by my great-uncle Thomas ("Jewel") Craven. Uncle Jewel was the family celebrity, a famous and controversial art critic of the thirties and forties. He crafted impeccable sentences, then wielded them like brass knuckles against selected artists ("psychic inbreeding has dulled their wits"), critic-gurus (Alfred Stieglitz: "he could gaze into space and receive affirmative blessing for whatever his ego dictated"), and museums (which "foster the notion that art is something ancient and inaccessible, instead of a decent job performed by an intelligent workman for an honest audience")—to quote a few choice haymakers from Craven's book, *Modern Art.*

Uncle Jewel was ill disposed toward cubism, abstractionism, and the works of Picasso; he also balked at accepting photography as an art form (although he admired Stieglitz's photographs and enjoyed quarreling with the old man). Not surprisingly, my great-uncle's criticism fell out of vogue. That is a loss because—differences of opinion aside—he has an approach to art and artists that was both sensible and passionately human. While decrying works that were mawkish, sentimental, or merely physically seductive, he felt that art

> …must ask for the cooperation of our noblest faculties, emancipating our emotions and stimulating us to feel and live deeply and liberally.…In short, it must act upon the spirit

and lift us out of our daily round of mean preoccupations into a realm of purging tragedy, exhilarating joy, profound human pity, dramatic power.

The man or woman capable of reaching into the spirit and bringing us into contact with the greatness of our humanity must, above all, possess a robust feeling for life. Uncle Jewell was not patient with those who cloaked themselves in neurosis, melancholy, and self-pity for Art's sake.

I'll confess that I had not looked at my great-uncle's criticism for years. What prompted a rereading was a visit last summer with Cole Weston at his enclave in Garrapata, California. Our only previous meeting had been in 1978 in connection with the landmark monograph on his father, *Edward Weston: His Life and Photographs.* A remarkable change had taken place. The change was not in Cole personally. He has been a photographer, teacher, theater director, yachtsman, businessman, and occasional political gadfly in nearby Carmel, where artist and developer live in perpetual disharmony. Unlike the dilettante, dividing himself among many interests, Cole seems to have the ability, the sheer vitality and power of concentration, to fulfill each of these diverse roles. And whenever he walks out of a room, you have the damndest feeling that more than one person just left. Twelve years had not even slightly diminished his overflowing measure of that genuine and exceptional interest in living that my great-uncle so valued in an artist. Yet there had been a change, and it was in full view upon the walls of his gallery.

When we first met, Cole was primarily occupied—in his words—as "the keeper of the flame" of Edward Weston. In that capacity alone, he made an incalculable contribution to the history of photography. The elder Weston won his own niche, of course, as one of the greatest artists of the medium. But it was his youngest son's efforts that brought Edward's images to many thousands of viewers, especially among younger generations, through prints, lectures, exhibitions, and publications. With the possible exception of Paul Strand, no photographer has been so well served for posterity.

When exhibiting previously at Garrapata, Cole displayed his work in groupings that would include photographs by his father, his brother Brett, and often his son Kim. It was a modest participation, and also appropriate. Cole is one of the pioneers of color photography, but in the first thirty or so years of his career he achieved relatively few images of greatness. My starting criteria for a "great image" was set forth by a friend of Cole's, the superb photography editor

Carole Kismaric: "a photograph that shows us something we have never seen before, or shows us what we may often have seen but never in this particular way." Cole had always been an excellent photographer, but something in him had—except in rare instances—held back. The long years of serving his father's vision had inhibited his own. Cole acknowledged it and promised that one day he would abandon his Edward Weston printing labors and see how far he might take his own photography. This liberation occurred three years ago, and the results were astonishing. By August 1990, Cole filled his gallery solely with his own photographs—images of extraordinary power, resonance, and beauty. He had, as he put it, finally claimed his birthright.

Cole writes of this birthright simply as photography. I'm haunted by the notion that it is something at once more specific and more mysterious: the Weston vision. It is a way of seeing, of confronting, and ultimately of conveying beauty through the photographic image. Virtually any subject matter will serve this vision, provided that it possesses for one eternal instant a quality of stillness. In that instant, the Weston vision appears to strike the essence of ideal form revealed in nature. As the fifteenth-century polymath Leone Battista Alberti wrote, "Nature produces the material, but genius brings forth the form." The Weston vision is the stuff, albeit metaphysical, of genius and it is unique to this family.

Having offered so thoroughly arguable an idea as a Weston vision—shared but with individual variations among a father and two sons—I'll venture further. I suspect that it originated not with Edward, but first manifested in his physician father. Dr. Weston was one of the great archers and proponents of archery in America. And there is probably no human activity more akin to the photographic genius for instantaneity than archery. As Eugen Herrigel wrote in *Zen in the Art of Archery:*

> In the case of archery, the hitter and the hit
> are no longer two opposing objects, but are
> one reality. The archer ceases to be conscious
> of himself as the one who is engaged in hit-
> ting the bull's-eye which confronts him. This
> state of unconsciousness is realized only
> when…he becomes one with the perfecting
> of his technical skill.

It one accepts the concept of a Weston vision, the question then becomes: Why did Cole wait so long to accept it? Brett seems to have fully discovered his legacy in his early teens and fulfilled it through seven decades of magnificent, productive photography. Only part of Cole's delay lies in preoccupation with his father's work and the technical constraints of color photography. I believe that Cole had to wait these many years to bring something new and very important to the Weston experience—and that is the richness of living.

Life, basically, is human relationships. Edward was a rather shy man, devoted to his work and limited to a few deep friendships—almost exclusively among artists. Brett took the isolating obsession with photography to even greater extremes, admitting to being ruthless with family and friends to preserve ample time for his work. Cole is the opposite, a gregarious man who genuinely loves the companionship of his fellow humans—strangers as well as intimates. This is a rare quality among artists, particularly among photographers. It is also time-consuming, and this is where much of Cole's time has been invested. It is his humanity—as much as his choice of color—that infuses his emerging mastery of the Weston vision with a new dimension, a relish for life.

That Cole has accepted his visionary legacy in his seventies is not dismaying for two reasons. In artistic terms, he now seems to be compressing many years of work into a relative few—his *anni mirabili*. Another of the century's fine teachers and artists, Lisette Model, once told me that in a long working life even a photographer of genius could expect to achieve only fifty or sixty masterpieces. "The only exception," she sniffed in an inimitably Model aside, "would be Cartier-Bresson. He probably has a hundred—but that's only because he shot twice as much film as anybody else."

Another reason is that Cole, having completed one biblical span, seems to be embarking on another with irrepressible energy and vigor. I have never heard any photographer speak of the medium with such a sense of joy, freshness, and discovery. It is this quality of youth and gladness, those wonderful early years of poets described by Wordsworth, that fills Cole's most recent work. He is like a happy young warrior, charging off to battle and glory. It seems to me that Cole Weston's photographs reverberate with the exuberant verse of another young warrior, Julian Grenfell, written on the eve of a World War One meeting with destiny:

> And life is colour and warm and light
> And a striving evermore for these.

R. H. Cravens

R. H. Cravens, a contributing editor to *Aperture,* writes frequently about photographers and is the author of *Edward Weston* and *Brett Weston: Photographs from Five Decades.*

EXHIBITIONS

CW is Cole Weston, EW is Edward Weston (Cole's father), BW is Brett Weston (Cole's brother), KW is Kim Weston (Cole's son).

YEAR	GALLERY	WHO	WHERE
1971	Focus Gallery	CW	California
1975	Afterimage Gallery	CW	Texas
1976	Witkins Gallery	CW	New York
1976	Susan Spiritus Gallery	CW	California
1977	Columbia Gallery of Photography	CW	Missouri
1978	Albright-Knox Gallery	EW, CW, KW	New York
1979	Marshall-Myers Gallery	CW	California
1980	Photography Southwest Gallery	CW	Arizona
1981	Halsted Gallery	CW	Michigan
1982	Photography Gallery International	CW	Japan
1983	Weston Gallery	CW	California
1983	Esders Gallery	EW,CW	France
1984	Yellowstone Arts Gallery	CW	Montana
1984	Focus Gallery	EW, BW, CW, KW	California
1984	Galerij Voor Fotografie	EW, CW	Belgium
1984	Jeb Gallery Inc.	EW, CW, KW	Rhode Island
1984	Catskill Center for Photography	CW	New York
1984	The Photographic Museum of Finland	EW, BW, CW, KW	Finland
1984-88	Foto Galere, Amsterdam	EW, BW, CW, KW	Holland
1984	Foto Galere, Amsterdam	EW, BW, CW, KW	Italy
1984	The Wach Gallery	EW, BW, CW, KW	Ohio
1985	Equivalents Gallery	EW, BW, CW, KW	Washington
1985	Images Gallery	CW	Ohio
1986	Camera Obscura Gallery	EW, CW, KW	Colorado
1986	Monterey Peninsula Museum of Art	Group	California
1986	Fresno Art Center	Group	California
1986	Triton Museum of Art	Group	California
1986	Sierra Nevada Museum of Art	Group	Nevada
1986	United States Information Agency published Spanish Catalog of "Weston Years" Traveling Show		
1987	Royal Houses Museum, Santo Domingo	Group	Dominican Republic

YEAR	GALLERY	WHO	WHERE
1987	New England Photographic Workshops	EW, CW	Connecticut
1988	Museum Modern Art, Mexico City	Group	Mexico
1988	Exposition Center, City Hall, Montevideo	Group	Uruguay
1988	Bi-National Center, Lima	Group	Peru
1988	Casa de Cultura Edcuatoriana, Quito	Group	Ecuador
1988	Banco Center, Guayaquil	Group	Ecuador
1988	Cuenca	Group	Ecuador
1988	University Museum, Caracas	Group	Venezuela
1988	The Photographers Gallery	CW, KW	California
1988	A Gallery for Fine Photography	CW	New Orleans
1988	Ulrich Museum of Art	EW, CW, KW	Kansas
1989	Israel Museum Jerusalem	Group	Israel
1989	Kunsthalle Tubingen	EW, CW, KW	Germany
1989	Fotoforum Bremen	EW, CW, KW	Germany
1989	Josef-Albers-Museum, Bottrop	EW, CW, KW	Germany
1990	Fotografie Forum Frankfurt	EW, CW, KW	Germany
1990	Stadt. Galerie Erlangen	EW, CW, KW	Germany
1990	Modern Art Center Koln	EW, CW, KW	Germany
1990	Kunstverein Gottinger	EW, CW, KW	Germany
1990	Museum Munster	EW, CW, KW	Germany
1990	Nikon Live Galerie, Zurich	EW, CW, KW	Switzerland
1990	Laguna Beach Gallery of Photography	CW	California
1990	Silver Image Gallery	Group	Washington
1990	The Boca Museum	Group	Florida
1991	Amerikahaus Berlin	EW, CW, KW	Germany
1991	Amerikahaus Munchen	EW, CW, KW	Germany
1991	Kunstverein Ludwigsburg	EW, CW, KW	Germany
1991	Strasbourg	EW, CW, KW	France
1991	Monterey Peninsula Museum of Art	CW	California